MAVERICK

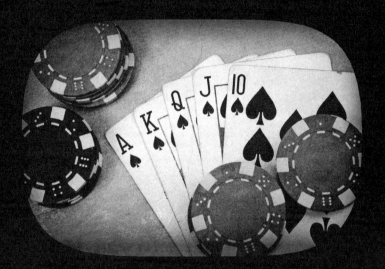

Dennis Broe

TV MILESTONES SERIES

Wayne State University Press Detroit

19 18 17 16 15 5 4 3 2 1

ISBN 978-0-8143-3916-9 (paperback); ISBN 978-0-8143-3917-6 (ebook)

Library of Congress Control Number: 2014954157

To Sri, who taught me what it is to work

CONTENTS

ACKNOWLEDGMENTS

This book was for me not only a labor of love but also a project in which I learned to love labor. I developed discipline in writing it, and I also learned that no author writes alone. This is to acknowledge all the help I received. I would like to thank my uncle Jerry Broe, who loved the series and would bring his family to our house every week to watch it. His enthusiasm was infectious. For their timely aid in supplying me with TV series and books, I would like to thank Rachel King, the media librarian at Long Island University; Lisa Burwell, the Long Island University interlibrary loan librarian; and Samantha Menard, my researcher and all-around great grad student. To them I must add Bradley Laboe for his technical assistance and comradeship. To write the book is one task; to enjoy writing it is another. This one was enjoyable, and for that and for their continual support in my development as a writer I would like to thank Phoebe, Karl, John, Brian, and Valentin. Always, I must thank Jerry Mundis for his writing wisdom that, as usual, was both efficacious and abundant. Finally, I would like to thank the members of my two writing groups: Judith, Dan, and Matilde, for being the best audience any writer could ever have hoped for, and Larry, Nona, and Pat, for their continued support even in trying times.

Introduction

Hell Hath No Fury Like a Cowboy Scorned

1

Maverick's eponymous theme song claimed that "Maverick is the legend of the West," but in fact the series was nothing of the sort. In some ways, with its emphasis on the itinerant lifestyle of a gambler, it was not even a Western. If it contained some of the iconographic trappings of the genre—including the mandatory fistfights—it shunned or subverted many of the crucial features, beginning with its outsider hero who was more interested in avoiding trouble than confronting it. As the series bible put it, Maverick, who thrived not on the rigors of the range but in the indolent playground of the saloon hall, was if not outright "cowardly" at least "cautious." The series was the first to introduce to the television Western not only humor but also parody, famously travestying the "traditional" Western of the day *Gunsmoke* (1955–75) with the episode "Gun-Shy," which featured a buffoonishly rigid sheriff. The parody included a mock-up of the opening gun duel credits of its more prestigious cousin shot through the outsized derriere of the bloated lawman, emphasizing not his power but his inflated

girth. *Maverick*'s mock Matt Dillon, Mort Dooley, was closer to Orson Welles's gargantuanly blubberous corrupt border official in the previous year's *Touch of Evil* (1958) than Gary Cooper's heroic sod in *High Noon* (1952).

The humor effected, at least momentarily, a change in the tone of the Western, enabling its audience to laugh at the seriousness of a genre that was intimately bound up with empire building. Introjecting comedy into the Western was also a commercial decision by the fledgling network ABC as a way of taking on its main competitors in *Maverick*'s Sunday time slot (Jack Benny, Steve Allen, and Ed Sullivan), a gamble that worked, as the series bested all three in its first season and won an Emmy in its second.

The humor, closer to whimsy and satire than the usual television belly-laugh comedy, along with the irreverence and iconoclasm, were the result of a melding of the minds of *Maverick*'s producer, Roy Huggins, and its star, James Garner. Huggins was an ex-leftie who retained from his radical days a strong antiauthoritarian bent and a sense of capitalism as one big crapshoot or societal poker game in which the odds were most often against the ordinary player but in which there was pleasure to be had in running the table against those stacked odds. Garner's refusal to take himself seriously, his sense of fun in the life of a drifter where work was devoutly to be avoided, came out of his early life as a vagrant fleeing responsibility and from his equal diligence in never confusing himself with a great "actor" who is "working" at his craft. He was instead content simply to project on the small screen his easygoing personality. Garner talked of acting in the entertainment business in the same nonchalant way as that other nonactor, the big-screen natural Robert Mitchum, an original Wild Boy of the Road, a hobo who claimed to have ridden into Hollywood on the rails and that in his Hollywood career of more than forty years he was always just in town "between trains" (Server, 14).

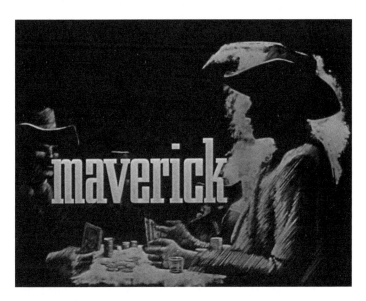

The Legend of the West.

While working within the rather rigid boundaries of the genre and sometimes appearing more iconoclastic on paper in terms of how it was talked about than in what actually showed up on the small screen, *Maverick* nevertheless was a series that effected change in three areas. First, the series modified practices in the television industry by innovations in both the formal way a series was structured, with its alternate lead Maverick's, and in its creative personnel opposing the "feudal" Hollywood studio system as applied to television, specifically in terms of actors' contracts and producers' credits. Second, the series also changed the form and content of its genre, the Western, undercutting its seriousness in a way that questioned the values of the genre and brought the then just emerging revisionist Western from the big screen to television. Finally, *Maverick* contributed to a larger change in the society as a whole by quietly opening

up a countercultural, antiauthoritarian space in the American heartland by way of the American living room.

The book's four chapters detail four levels on which the series functioned innovatively. Chapter 1 traces how *Maverick* both conformed to and challenged the policies and mode of production of Warner Bros. and Hollywood in the period that marked the end of the classical studio era in the cinema but featured more regressive forms of that policy applied to television. The chapter details the rigid assembly-line procedure of the studio's strictly for-profit system and how that rigidity alienated not only creative artists who challenged the precepts of the factory system but also the television sponsors such as *Maverick*'s Kaiser Aluminum, which was not happy about a cookie-cutter approach that, often due to contract disputes, led to four quasi-identical Mavericks in four seasons.

Chapter 2 describes the show as being a television revisionist Western at a moment that almost anticipated this reversal of the values of the genre in the cinema. *Maverick*'s run from 1957 to 1962 was sandwiched between the peak years of two conservative Westerns that defined the genre, *Gunsmoke* (1955–75) and *Bonanza* (1959–73), both of which *Maverick* parodied. The gambler Bret Maverick, rather than being a lawman as in the former or a wealthy landowner as in the latter, was a drifter who often ran afoul of the corrupt or rigidly legal McCarthyite sheriffs who frequently inhabited the towns through which he roamed and who were more likely to run him out of town than to see him as a western property owner. This drifter and live-and-let-live ethos reflected an alternative value scheme at the time that was foreign to the Western. The show's view of the West as a site of speculation and corruption at the peak moment of the Gilded Age linked it to satirical representations of the West by such authors as Mark Twain and Herman Melville and stood in contrast to the standard view of the West as heroic embodiment of the pioneer spirit.

Maverick's lifestyle—he was constantly on the move in a way that mapped the entire Western landscape and was always looking for the best poker game, that is, a site where he could exercise his own form of creativity, fun, and pleasure—linked him to both a long line of bohemians and the contemporary beats. Chapter 3 explores *Maverick*'s lineage in the nineteenth century in the flâneur—the Parisian gadabout—and his link, in his aversion to work, to the attack by Paul Lafargue, Karl Marx's son-in-law, on the Calvinist ethic in his "right to be lazy." Maverick's staging of creative events, under the name of scams, links him to another Parisian movement, that of the situationists. In the United States the situationists' ethos was in a different way taken up by the beats, whose lifestyle would be incorporated even more assiduously in a future Huggins series, *The Fugitive* (1963–67).

The fourth innovative area was an intervention in the cultural climate of the country that cannot but be read as also taking a position on the omnipresent Cold War. The Western, with its violent means of settling arguments, was a crucial site at which to situate a critique of policies of mutually assured destruction that were driving the confrontation. The Mavericks were not particularly proficient with weapons, often settling disputes not through gunfights but through elaborate scams. They also frequently ran afoul of the often overzealous (read: sadistic) or corrupt guardians of the social order in a way that questioned the precepts of armed confrontation at a moment when Cold War tensions were easing. The antiauthoritarian versus law-and-order discourse, outlined in chapter 4, was a decades-long argument between Maverick's producer Roy Huggins and *Dragnet*'s (1951–59) McCarthyite creator Jack Webb that was here just taking shape.

Bret Maverick was the quintessential outsider whose morality focused on peace and pleasure in a violent landscape. His efforts frequently went unrewarded and sometimes unacknowledged, as when he describes his mainstream rival in "The Saga of Waco Williams": "He did everything a man should not do.

But he's still alive. Looks like he'll be elected sheriff. I know he'll end up with the biggest ranch in the territory. And I'm broke. Nobody even knows I'm leaving—or cares. Could I be wrong?" Maverick's less confrontational and more easygoing live-and-let-live morality was not wrong; it was just ahead of its time, as was the show that bore his name.

Warping Warner's Wranglers

Maverick's Challenge to the Studio Western

The commercial constraints on television make it extremely difficult even today for writers and other creative artists to establish control of what is said to be a writers' medium. *Maverick,* partly because of its overnight commercial success, went some way toward changing that, establishing the predominance of the writer-producer who understood the series and the predominance of the lead actor who embodied the character's values. This series was responsible for wresting some degree of control from an ossified studio system attempting to transplant its feudal mode to the emerging medium of television.

This rigid profit-making machine that was the Warner Bros. factory system produced at the end of the studio era the equivalent of a feature film every day. In the late 1950s and early 1960s the studio was the single largest source for hour-long dramatic series, led by its Western, detective, and private eye series. The same inflexibility that was responsible for this remarkable feat of production was equally

responsible for its undoing so that by the autumn of 1962, only one of its Westerns survived. *Maverick,* which was the studio's biggest hit at the height of its popularity, commanded more than half of all active television sets and, in the way that it satirized the Western, played its part in the demise of Warner's premiere genre.

The two artists most instrumental in the look and feel of the series, its producer Roy Huggins and its star James Garner, also participated in crucial interventions that modified the power of the studio system in television. Huggins established the primacy of and a degree of autonomy for the writer-producer in a move that furthered the producer, and not the studio, being acknowledged as the creator of a series. At the same time, Garner won a legal suit and established the actor's importance in the creation of a character and his or her ability to have some control over how long and under what conditions that character would define the actor. *Maverick's* opening episode was emblematic of a central theme in this series and in Huggins's overall work: gambling as a descriptive metaphor of life under capital in general and of the life of a creative artist under the regime of capital accumulation in the entertainment industry in particular.

How the West(ern) Was Mechanized

The entry of Warner Bros. into television production was crucial in shaping the future of the medium. The studio was ceasing to be a site of film production and was transitioning instead to a site of distribution of the work of independent producers, signaling the end in Hollywood as a whole of the classic studio era. Warner Bros., which had earned $22 million in 1947 in profits from its film production and exhibition, having subsequently been forced to divest its theaters and just beginning to transfer over to bigger-budget blockbusters, earned only $2.9 million in 1953 (Anderson, 2).

Although Jack Warner, who now owned the largest share in the studio, had originally seen television as merely a means of publicizing film production, it soon became apparent that there was another even more productive use of the medium: as a place to reinstall the (perhaps more onerous) elements of the studio factory system that had been responsible for grinding out more standard, as opposed to prestige, films and B movie products in the 1930s and 1940s. Warner Bros., which by early 1959 had not a single film in production, instead moved head-long into television at a moment when the golden age of live television dramas (*The Philco Television Playhouse,* 1948–55) and independently produced sit coms (*I Love Lucy,* 1951–57) was coming to an end. The success of Warner's mass production of series television for the fledgling ABC network helped prompt the adoption of the weekly filmed series format.

The seminal moment in the studio's success was a pitch session in October 1956 with ABC that featured Warner's television supervisor, William Orr, and more crucially a Warner producer, Roy Huggins. Huggins, whose work on Warner's first television success, *Cheyenne* (1955–63), had saved the series by making it more of the adult Western that ABC wanted, pitched two series, both of which would revolutionize, if not destroy, their genres and would be the foundations of the studio's success. Both series, the Western *Maverick* and the crime series *77 Sunset Strip* (1958–64), based on a Huggins novel, added elements of pleasure and humor to what were grim-faced genres. *Maverick*'s "gentle grafter,"[1] a gambler with "more than a little larceny in his soul," and a new type of witty, urbane private eye "living the good life in Sunny California" were both commissioned as pilots and led to the studio building a million-dollar complex the next summer to swing into television production (Anderson, 224). *Maverick,* along with *Sugarfoot* (1957–61) and another Huggins-piloted series, *Colt .45* (1957–60), was one of three Westerns the studio ordered for the 1957–58 season and, along with *77 Sunset Strip* and its various imitations,

9

was responsible for a transformation of ABC so that by 1958, this perennial second fiddle to CBS and NBC won the ratings race the majority of nights each week in the top twenty-four markets (Anderson, 246).

Warner Bros. then began to revise and streamline low-budget production in ways that, as Christopher Anderson notes, were closer to the poverty row, bottom of the barrel B movie studios (172). They revived the producer-unit system, which applied to television meant that individual producers specializing in generic types of content might be responsible for multiple shows. Yet each was still under the hierarchical management of William Orr and ultimately Jack Warner. Elsewhere the studio organized story and production departments that oversaw both elements not for a single series but for all the series, thus promoting shared or recycled plots, dialogue, and locations.

The attempt was to limit the autonomy of the creative personnel whereby, for example, no single writer would be allowed to create a series or to move it beyond the preestablished format, since ideas would be generated from the story department and then executed by writers hired only for a single script.[2] Additional components of this "rigorously controlled production process" were exclusive long-term contracts with actors (the standard being seven years) and producers and a revival of studio shooting at a time when films were more frequently opting for location footage (Anderson, 179). Thus, Warner Bros. attempted to dominate on television not through the strength of its vision but through its sheer productive capacity that, with the studio accounting at its height in 1959 for one-third of ABC's prime-time schedule, allowed it to output the equivalent of one feature film *per day*.

This production "miracle" was based on the routinization of the product, the "willingness to sacrifice originality for economy" (Anderson, 180). Thus, the Western model, established in the studio's first hit *Cheyenne,* fell into the category of the stalwart wanderer through the Western landscape (or studio

back lot) who each week encountered and usually rescued someone in that landscape. This combination of unwavering series character with the golden age television drama anthology format allowed the studio to pilfer and recirculate a wide variety of film scripts with various characters and settings. What the studio in fact discovered was a new way of extending its back catalog vis-à-vis television beyond the simple rental of old films to the networks. The films' component parts (plots, music, footage) could be reassembled piecemeal into weekly series. Thus, the Westerns used Warner Bros. library footage almost whenever there were action sequences, blending studio long shots of, for example, a posse or riders on the plains with insets of the characters in locations that often only loosely matched. Garner claimed that *Maverick* ventured off the Warner Bros. back lot only "once or twice in three years" (Garner and Winokur, 56) and that in an episode based on the Errol Flynn film *Rocky Mountain* (1950), in order to match reused footage, Garner "wore Flynn's hat and vest" (Garner and Winokur, 51). He reported that a joke around the set was that if the shot had more than two characters, it most likely used stock footage (Garner and Winokur, 51). The series also had a similar visual look because the original footage was shot on Warner's single Western street, where camera personnel often shot different series back-to-back.

Stories and dialogue were also recycled first from the films and then from series to series. Scripts and actors were thought of by the studio as interchangeable. This recycling reached its zenith, or nadir, during the 1960 Writers Guild Strike when Warner's hyphenated writer-producers, who were allowed to work by the guild, assembled scripts under the pseudonym "W. Hermanos," Spanish sobriquet for "Warner Bros." One wag claimed that their ransacking of plots from older Warner Bros. product might even include WB cartoons and specifically Bugs Bunny, where "there might be a *Maverick* or two" (Anderson, 271). Roger Moore had starred in the single-season *The Alaskans* (1959–60)

before appearing as Beau Maverick and claimed to have already been familiar with his new series, because not only plots but actual dialogue had been lifted from episodes of his previous series.[3] The studio also had a mass-production schema for its television music. Each show had a theme that could be repeated in endless variations on the individual episodes, with most additional music pulled from Warner's music library and simply inserted at the proper emotional moment (Robertson, 59).

Eventually, though, this production-line assembly led to oversaturation of a similar product and was partly responsible for the studio's loss of dominance. Warner's omnipresent use of product placement and promotion of its own series, for example, could backfire and instead simply present a portrait of factory-line production. In "Hadley's Hunters," the second episode of season four (1960–61) of *Maverick* when the show had started to plummet in popularity, Bart runs into the stars of the other Warner series *Lawman* (1958–62), *Cheyenne* (1955–63), *Sugarfoot* (1957–61), and *Bronco* (1958–62) and even for good measure Edd Byrnes, the carhop from *77 Sunset Strip,* presumably out West parking horses. However, the star-studded array may have served only to show how similar all the characters were, since most of their shows would go the way of *Colt .45* (1957–60), mentioned in the *Maverick* episode, and soon be cancelled.[4]

Warner Bros. is perhaps the strongest current studio presence in television and still continues to follow the tried-and-true production methods, with its main hits being produced by Chuck Lorre and consisting of a formula of blatant and often misogynist sex jokes played out among Malibu bachelors (*Two and a Half Men,* 2003–15), nerds and computer geeks (*The Big Bang Theory,* 2007–), and even recovering alcoholic women (*Mom,* 2013–). The CW network itself, a fusion of Warner Bros. and Paramount, in a rigidity that echoes 1950s Western male heroes, features a mandatory lineup of series involving clean-cut and often wealthy young people, the newest wrinkle of which is producer Craig Berlanti's hunky superheroes who sometimes

actually fight upper-class crime (*Arrow,* 2012–; *The Tomorrow People,* 2013–14; *The Flash,* 2014–).[5]

Too Much of a Mediocre Thing

Warner's application of a rigid production system for television met with resistance at both the distribution end by its network ABC and its sponsor and at the consumption end by audiences who eventually voted against the system with their feet, or rather their fingers, by switching the television dial. When in 1955 ABC initially commissioned *Warner Bros. Presents,* a show that alternated three of the studio's genres, the network expected the sense of spectacle that characterized then emerging higher-budget Hollywood blockbusters such as 1953's cinemascope *The Robe.* Instead, the network reported, it got "impoverished sets and generic costumes . . . amateurish acting and clichéd writing . . . [and] bland visual style and confused editing" (Anderson, 197). The studio was instructed that it needed to "generate more compelling stories" from its series formats that would more thoroughly invest the audience in its characters (99). The drive toward cost cutting was so great that the writer of its alternating Western *Cheyenne,* Maurice Geraghty, asked to have his credit deleted from the first episode because he felt that his work was ruined in the abbreviated production and postproduction process.

The studio made some superficial changes in format and a major change in the content of *Cheyenne,* moving it into the adult Western category that the network and sponsors sought, but the studio's drive toward standardization of product continued as its success increased. Under this system the teleplay was seen not as a moment of unbridled, or even bridled, creativity but rather as a blueprint for controlling costs and imposing a tight shooting schedule that was about conformity rather than creativity. This was achieved through procedures such as removing scenes that required complex setups or different sound

13

stages and keeping the action centralized for the directors hired short-term to shoot. The postproduction phase was routinized by requiring that the editors assemble the footage with a maximum of four passes per episode (Anderson, 251).

In addition, the characters in the series were said to be interchangeable; thus, the Bret and Bart Maverick scripts were written for either character, with the brothers delineated as "Maverick 1" and "Maverick 2," as were the Stuart Bailey and Jeff Spenser scripts for the two private eyes on 77 Sunset Strip. Stories were recirculated not only among but also between genres, as was the case with the 77 Sunset Strip pilot "Lovely Lady, Pity Me," remade on Maverick as "The Lass with the Poisonous Air." The formula was endlessly spun off, as 77 Sunset Strip with its good-looking, debonair detectives in exotic locales became the Honolulu-centered Hawaiian Eye (1959–63), the New Orleans–centered Bourbon Street Beat (1959–60), and finally the Miami-centered Surfside Six (1960–62), with the studio seemingly unconcerned about the public's saturation limit. Television supervisor Bill Orr boasted that when series star Clint Walker refused to act in Cheyenne because of a contract dispute, Orr talked ABC into broadcasting reruns the entire season, which resulted in the studio receiving half the profit of the previous season "without expending a nickel" (Wooley, Malsbary, and Strange, 81).

The end result of this miserly rigidity was that the network, ABC, as well as the studio nearly collapsed. "All our shows began to look alike," claimed network programming chief Tom Moore, and a popular piece of doggerel at the studio ran "I think that I shall never see / A format new for ABC" (Anderson, 280). In the wake of this saturation, the network lost much of its audience and was only rescued from a decade of low ratings by Huggins again, this time with The Fugitive, his contemporary Western about a sympathetic convicted felon. The collapse of the studio's television division was equally dramatic. In 1962 television profits were nearly the same as film profits, but in

the wake of a disastrous appointment of Jack Webb to head the division, by 1965 television accounted for only 21 percent of profits, a decline that was signaled with the laying off of 25 percent of the television production staff in 1962 (Anderson, 283).

One of the studio's major cost-cutting initiatives—underpaying producers, writers, and directors—was perhaps most responsible for its loss of status and ratings. Warner Bros. refused to allow writer-producers to claim a "created by" credit on its series because the studio would then have to pay residuals on that credit in perpetuity. Producers were then underacknowledged for their work, with the studio taking the creative credit. Huggins had created the studio's two most popular properties, *Maverick* and *77 Sunset Strip;* had turned *Cheyenne* into the adult Western the studio had promised, giving Warner Bros. its first television hit; and had also created another series, *Colt .45.* Yet none of this was acknowledged, and by 1960 in dissatisfaction he had left Warner Bros. television and had taken with him the creative core of writers on *Maverick.*

That same year the studio's other irreplaceable cog, James Garner, won a court case against the studio and walked off the show, asserting later that "If Warners had paid me a decent wage in the first place, I'd never have sued, and they'd have had me for life" (Garner and Winokur, 67). Warner Bros. had claimed that all creative personnel were replaceable, but Huggins and Garner, the captains of the studio's flagship series, proved the studio wrong, because with their departure the series dropped from a high of a 51 share, that is, the percent of all televisions tuned in, to an average of a 32 share (Robertson, 210).

The deterioration of the series illustrates the fallacy of the studio's belief that creative personnel were simply replaceable. The first two seasons saw the series place consistently in the Nielsen Top Ten in its highly competitive time slot and win an Emmy in its second season. The first episode of the third season, with Garner and without Huggins, opened with a 49 share, but the new producer, Coles Trapnell, began altering the

series' conception, beginning with the opening episode titled "Pappy" in which he broke a Huggins rule of never showing the boys' father, whose witticisms, such as "He who plays and runs away lives to run another day," allowed the series' writers to push the character to exceed the bounds of the Western hero. Garner played his Pappy, but the visualizing of the character destroyed its mystique, and the next week the series dropped to a 37 share (Robertson, 167).

The third through fifth seasons, which in one stretch featured four producers in less than a year and consisted of Garner's replacement by two new Maverick family members, continued to alter the series' character from an outsider straddling the law with a wry sense of humor to a more respectable Western gentleman. The series also tried harder and harder for more open belly laughs and the result of the changes was a plummet in the ratings. The formerly cowardly Maverick appeared as a lawman in "The Sheriff of Duck 'n' Shoot," as a frontier attorney in "Maverick at Law," as a soldier in "Trooper Maverick," and as a candidate for state senator in "The People's Friend." Finally, in "The White Widow," Huggins's "grafter" was designated as the defender of a (female) bank president, the very opposite of his role as giving a comeuppance to a criminal banker in one of the series' most popular episodes, the Huggins-written "Shady Deal at Sunny Acres."

In the same way that Warner Bros. freely substituted producers, the studio attempted to substitute actors and with the same negative result. When Garner left the show the studio created a "Cousin Beau," inserting Roger Moore in that role as the Bart (Jack Kelly) alternate. The ratings fell with Moore and Kelly, and at the end of his contractual limit, fifteen episodes, Moore left the show, claiming that one reason for his abrupt departure was the poor quality of the scripts. (Moore was a very marketable television star, and his next series, *The Saint,* became an international hit, running from 1962 to 1969.) The studio then tried to fool the audience with Robert Colbert, a

James Garner look-and-sound-alike as younger brother Brent, forcing him to dress in Garner's outfit. The experiment ended after only two episodes, and the fifth and final season limped to a close, with Kelly alternating with Garner reruns.[6]

A Horse of a Different Color:
How *Maverick* Bucked the System

Maverick, despite Warner Bros. standardization, managed to distinguish and individualize itself in such areas as its form and content, its beginning to establish the primacy of producer over studio in television, and its victories for writers and actors in establishing a degree of autonomy. *Maverick*'s formal contribution to series television was to begin a trend toward a more sophisticated serialization that would not fully bloom for decades. This trend was partly born out of necessity. The show, which began with Garner as the lone Maverick, took six days to shoot and thus with extra days for editing could not possibly be output at the rate of one episode per week. The innovation was to introduce a second brother, Bart, and to have two production teams filming simultaneously, one for each Maverick. Bart was introduced in episode eight of season one, where he appeared with Bret, followed by episodes where Garner's Bret introduced the Bart episodes and finally episodes where Bart was a force on his own. The characters, though, not only alternated but also appeared in episodes together, with critics frequently citing these episodes, such as the aforementioned "Shady Deal at Sunny Acres" and "Two Beggars on Horseback," in which the two race to see who can con a company that has swindled them, as being among the more finely wrought examples of the series.

At this juncture, the idea of a continuing story was frowned upon because serialization seemed to suggest an affinity with daytime soap operas,[7] thought to be a less sophisticated form, and because ABC network executives believed that audiences were unable to follow a weekly continuing story (Anderson,

169). This mixing of regular episodes with more special episodes suggests a momentous evolution toward more complex serialization that would occur in *The X-Files* (1993–2002), with its alternation between regular anthology episodes and the episodes that detailed the continuing series mythology of government/alien conspiracy. It should also be noted that though the episodes were supposedly written for the Maverick brothers to be indistinguishable, in fact they were differentiated in performance by Garner's wit as opposed to Kelly's more straightforward nonchalance. Bret's lighter touch also seemed to work itself out in his looseness and equality around female relationships as opposed to Bart's more patriarchal attitude, expressed in the episode "The Spanish Dancer" in which he falls in love with the dancer and "offers" to turn her from an independent woman into his housewife.

18

A second innovation, this one in content, that grew out of the conditions of the mode of production, was the addition of the element of humor and parody to the Western.[8] This addition was also perhaps born out of necessity. In its 7:30 p.m. Sunday time slot, *Maverick* went up against two titans of innovative television comedy, Jack Benny and Steve Allen, and against comics incorporated into the Ed Sullivan variety format, so adding comedy to the genre was partially born out of an "if you can't beat 'em, join 'em" practicality. The humor was often self-deprecating, with Maverick shirking responsibility and refusing to play the hero. The character's passivity as well as his love of the larcenous, which Huggins claimed was inspired by the humor of Ben Johnson, despite the fact that the series was not "a comedy Western . . . but a Western with humor" (Huggins qtd. in Robertson, 19), opened up new possibilities for the genre as a site of American counter mythmaking. The show featured among its writers humorist Marion Hargrove, already famous for his equally deprecating army satire *See Here, Private Hargrove* (1942). His scripts such as "The Belcastle Brand"—adapted from "The Admirable Crichton," a turn-of-the-century British play by James Barrie about class difference—with Bret

The gambler at home in the saloon.

playing the part of butler to a family of royal tenderfoots, were distinguished for their sophisticated dialogue and were welcomed by Garner, an actor who, Huggins claimed, had "an unerring instinct for a funny line" (Robertson, 7).[9]

Maverick was also crucial in wresting creative power away from the studio. Against the dictates of the Warner Bros. system,

or rather at the heart of that system, the show helped establish the primary role in television of the writer-producer. Series creator Roy Huggins may have been part of an assembly-line mode of production, but his was, as that well-known television critic Jacques Derrida might say, the trace, the excess, that spark of originality that luckily for the studio it could not extinguish or routinize. Huggins was not the typical Warner Bros. producer, whose duties made them more supervisors than producers. He was a writer who wrote or rewrote all the episodes in his two-year tenure on the show and also likely conceptualized at least half of the storylines (Anderson, 276). This active participation made him the keeper of the character and the tone of the show.

In addition, and in contradistinction to the Warner Bros. story department of replaceable writers, Huggins assembled a repertoire of distinguished writers and directors led by Hargrove, whose habitual association with the show made him almost an "unpaid associate producer" (Robertson, 62). This core of writers became experts not in how to reassemble Warner Bros. properties but instead in the character of Maverick, with Huggins, Hargrove, and two other writers, Douglas Heyes and Howard Browne, writing the majority of scripts in the first two seasons and with Heyes, Leslie Martinson, and *Cheyenne*'s Richard Bare directing the majority of episodes (Robertson, 22).[10]

Huggins's ability to somewhat alter the Warner Bros. system was based on two factors: the immediate success of the series and his overall value to the company. The second episode of *Maverick* passed Steve Allen in the ratings, and by November the show had passed Ed Sullivan in the major markets, both having been thought to be impregnable in their shared Sunday night slot. Because of this success, sponsor, network, and studio were all loath to interfere with the production of what was Warner's first major hit series. In addition, as has already been stated, Huggins's role in creating new series and in fixing broken series such as *Cheyenne* was undisputed. By the 1959–60 season he was responsible for half of Warner's seven and a half

hours on the air, and it could legitimately be argued, as Maverick aficionado Ed Robertson claimed, that "he *was* Warner Brothers television" (161).

Huggins also contributed to establishing the power of the creative producer over the director on television. The first three episodes of *Maverick* were helmed by veteran Western director Budd Boetticher, who was just under midway in a series of seven successful screen Westerns starring Randolph Scott. Boetticher, as is common with a film director, gave a line of dialogue in the opening script stressing Maverick's if not cowardice then caution to another character. Huggins reshot the scene with the line delivered by Maverick and refused to use Boetticher again, ostensibly firing him because he had changed the character, trying to make Maverick into a more stalwart Randolph Scott–type Western hero, a characterization that Huggins rejected (Anderson, 233).

Huggins also established what is now commonplace for series, an abbreviated series bible that he called "The Ten-Point Guide to Happiness While Writing or Directing a *Maverick*," a document that is part standardization of the character and part revolt, since the character traits broke with Warner's Westerns as well as those of other networks and studios. One point states that "The cliché always flourishes in the creative arts because the familiar gives a sense of comfort and security. Writers and directors of Maverick are requested to live dangerously." Another point states that "In the traditional Western story, the situation is always serious, but never hopeless. In a *Maverick* story, the situation is always hopeless but never serious" (Robertson, 26).

The *Maverick* experience also began a step toward the establishment of the value of producers, writers, and actors and a further acknowledgment of their role in the creative process. The studio, which paid writers residuals on scripts they authored, refused to issue what has become the holy grail of television series, the "created by" credit that would mean paying a royalty to creators on any subsequent episode of the series in perpetuity no matter their involvement. Instead, Warner Bros.,

in an "elaborate fiction" (Anderson, 231), claimed that the studio itself authored the work. To ensure this, Jack Warner declared that every pilot had to be based on a property owned by the studio.

Huggins had written the *Maverick* intended pilot "Point Blank" but was told that since the episode was based on his original work, it could not be the pilot; instead, he must base the initial episode on a Warner Bros. property. To comply, he wrote what was the first broadcast episode, "War of the Copper Kings," which the studio could claim was based on the C. B. Glasscock nonfiction work of the same title that Warner Bros. had bought. Huggins used one element from the book, an obscure mining ruling called "The Apex Law," which he had used before in a treatment for a *Gilda*-type noir, *Antonia,* that the studio then also subsequently purchased to be able to claim ownership of that property as well (Robertson, 54). The studio's cancelling of the "created by" credit for Huggins on *77 Sunset Strip* was even more blatant; it opened an expanded version of the pilot in movie theaters in the Caribbean in order to claim that the series was derived from a Warner Bros. film.

Huggins eventually left the studio because of this kind of treatment, arguing with studio head Orr that he had to compromise because "You have twenty lawyers working for you and I have none" (Robertson, 162). Largely because of this experience, Huggins in his next broadcast job heading the television division at Universal studios proudly related that he established what came to be called "The Huggins Contract" in which producers are guaranteed a royalty fee for any show they create, no matter their involvement in the actual running of the show. Jack Warner's iron law had been "I will never pay royalty to any writer" (qtd. in Robertson, 133), and Huggins's refuting of that rule was his claim that at Universal "I was getting paid my royalty and my fee whether I did the show or not" (O'Shea). He received a measure of revenge when his old network, ABC, desperately needing a hit, came calling, and he pulled from

his desk a treatment that became *The Fugitive* for which he received a prominent "created by" credit, though he never actually worked on the show. Even Warner Bros. very belatedly acknowledged his pivotal role at the studio by bestowing the "created by" credit on Huggins in its 1994 *Maverick* film.

Garner won an equally momentous battle against the studio that went some way toward overthrowing the onerous long-term contract system and championed actors' rights to have some control over their persona, which in television often consisted of an even more rigid typecasting than in the cinema. Warner Bros. had a long history of almost feudal treatment of its actors, binding them to lengthy contracts that left them little control over their careers. Humphrey Bogart, Bette Davis, and James Cagney were all at one time in protracted—and losing—legal battles with the studio.[11] The studio's claim that it was "almost completely responsible for the market value of its actors" carried over to television, where its goal was to use the new medium to make stars of unknown actors who could then also star in the studio's films at the same low wage they were signed for on television (Anderson, 239). Garner was offered a minuscule wage increase the day *before* the studio announced him as the lead to replace another disgruntled actor, Charlton Heston, in the 1958 feature *Darby's Raiders* (Garner and Winokur, 50). Actors at Warner Bros. also received little compensation for public appearances, including those on other television shows, and did not receive merchandising residuals, which in the wake of the coonskin cap craze of Disney's *Davy Crockett* (1954–55) could be quite substantial, with that series producing approximately three thousand products for sale (MacDonald, *Who Shot the Sheriff?,* 40). *Cheyenne*'s Clint Walker watched as the studio and its sponsor marketed clothes, games, and even cigarettes based on his character, despite his protesting of the latter because he did not smoke (Yoggy, 193).

Warner Bros. television actors rebelled, as did the film actors of the previous era. Walker in *Cheyenne,* Wade Preston in

23

Colt .45, and Edd Byrnes in *77 Sunset Strip* all at various points walked off the set because of their low return on the profits they were making for the studio. Walker, who described himself under the terms of the contract as "like a caged animal pacing back forth in a zoo" (Anderson, 273), earned $500 per week for starring in a top-twenty series and for also being cast in films, an amount that Garner, who earned the same, described as "not a lot of money for the time" (Garner and Winokur, 55). This return was especially outrageous, since Huggins claimed that the series "brought in over $8 million" for the studio (Yoggy, 238). Garner added, in sympathy with Walker, "He got nothing because Warner Brothers gives nothing" (Strait, 164). Walker was replaced for a season on the show with a new character, Bronco Lane, and grudgingly returned to be followed by other actors challenging these contracts, collectively described as "an outdated form of servitude" (Anderson, 274).

There were subtler protests as well. The producers forced actors to punch in on a time clock. Roger Moore claimed that he refused to punch in and that Jack Kelly, who came from a professional acting family, would demonstrate his disgust by using the clock as a football (Moore). The situation was so onerous that in 1959 Garner, appointed to the Board of Governors of the Screen Actors Guild, held a meeting at his house for fellow actors to complain about back money the studio owed them. Because of the volume of the offenses, the guild threatened to forbid its actors from working at the studio, a threat that finally caused the studio to pay the wages it owed (Strait, 144).

The weightier blow, though, was leveled single-handedly by Garner, who contested the studio's power and won, striking a blow for all actors against the power of this industrial machine. Warner Bros. laid off Garner and Kelly during the 1960 Writers Guild Strike, claiming that the studio was not required to pay its actors because of the halt in production. Both, however, were still scheduled to do film work, and the studio's writer-producers continued to crank out scripts during

the strike under the "W. Hermanos" pseudonym. Garner and Kelly then sued to abrogate their contracts, claiming that with the appearance of these scripts, the studio was not hampered from producing the series. Kelly, by his own admission, was bought off, exiting the lawsuit and leaving his co-lead alone at a time when Garner badly wanted to leave both the show and the studio, which he declared was treating him "like a slab of meat. Every once in a while they cut off a piece" (Anderson, 273).

The studio finally offered Garner, whose presence was the only thing distinguishing the show after Huggins's departure (Robertson, 209), more money. In addition, the sponsor, Henry Kaiser, who owned one-third of the show, offered Garner one-third of his share. Nevertheless, Garner persisted with his lawsuit even though he was threatened by the studio that if he continued, he would "never work in this town again" (Garner and Winokur, 65). He won the suit and his freedom from the studio partly based on the arrogant testimony of Jack Warner, who in boasting of his ability to run the studio without writers inadvertently backed up Garner's claim that the studio could have continued production (Garner and Winokur, 66).[12]

Not only did the court rule that Garner's contract was void and he was free to leave the studio, but also, on appeal, the court granted an injunction forbidding Warner Bros. from interfering with prospective employers, that is, carrying out its boast to blacklist him. The decision, the first major case to be won by an actor against the company since Olivia de Havilland won the right to not have her contract extended in perpetuity, was a major blow against the studio system. Garner left *Maverick* for a film career and struck a blow for television actors having some say in the extent their career would be dictated for them. Garner was the first to escape what he called the "Warners Penitentiary" (Yoggy, 238), and Huggins appraised the decision as the "biggest break any actor ever got because he was free to pick and choose whatever he wanted to do thereafter" (Strait, 165).[13]

"Living on Jacks and Queens":
The Artist as Itinerant Gambler

With the studio being such a strong and controlling presence in the life of its creative personnel, it is almost inevitable that aspects of the show might itself be a comment, under the nose of Warner Bros., on that presence. The show indeed functioned as an allegory of the specific mode of production under the television studio system that could not help but also be an allegory of the wider mode of capitalist production as a whole, since the studio exemplified the values of a more centralized and hierarchized form of 1950s corporate capital in the service of profit (Horowitz). Huggins's means of expressing this condition, a theme in his work that he returned to later when he teamed with Garner again in *The Rockford Files* (1974–80), was to see the studio and economic enterprise as a whole as akin to a crapshoot. The metaphor for this system in *Maverick* was the gambling table, where the rules are most often set in advance and the odds are stacked against the (artist/worker) players but where through their creative initiative they were intermittently able to reverse the odds and emerge triumphant.

26

Most often, though, on the series they were quickly whisked out of town or, in the case of the Warner Bros. writers, shifted onto another series, able to leave only a faded mark (often not even credited or paid for their work) on shows where they had been and on how they impacted the town, the show, and the studio. Nevertheless, the show itself is potentially their moment of distinction where, using only their wits (as does Maverick), they triumph if only momentarily over an entrenched power structure that most often is trying to obliterate them.[14] The momentary victories of Bret Maverick and Jim Rockford against stacked odds are also the (working- and middle-class) audience's, which must daily battle these same odds in a system where (economic) power usually holds all the cards.

Though Huggins called "The War of the Silver Kings," the first episode imposed by Warner Bros., "the only show of mine that was inconsistent with the tone and concept" (Robertson, 53), he lodged a critique of the studio and the economic system under the guise of a simple story about a gambler who changes a town. The show opens with a grizzled horseman in frayed leather jacket carrying a rifle riding into a typical Western town, no different than the other Warner Bros. Western characters. Once inside, Maverick finds the power of the town allayed against him and bluffs, or uses his wits, to prevail in what will be the dominant motif of the episode and indeed of the series. The room clerk at the hotel tells him that there is no room for a dusty cowboy, but Maverick shows him an envelope reading $5,000, with a $1,000 bill face up and the rest of the "bills," we know, being newspaper clippings Maverick has stuffed inside the envelope. The clerk immediately changes his tune and ushers in Maverick who, a bit disgusted over the clerk's utterly defining him by his money, motions to him to carry his bags. The opening scene then describes the town of Phineas King, the silver king, where money rules utterly; the town in the analogy being the studio and the silver king being Jack Warner. The episode also shows how, if fleetingly, those values could at least briefly be thwarted by a gambler using his wits, which Maverick, now in gray vest and black suit, reveals himself to be.

King is introduced at a poker game talking about a worthless mine. He claims that if the mine had value "I would have absorbed it long ago," highlighting his utter control of the town through its silver mining economy. Maverick, when asked his profession, describes himself as a grass inspector, "the kind that's greener in the other fellas' yard," that is, as someone who lives by playing on other people's folly. Maverick outwits King a number of times in the show and initially at the poker game when, after gambling away his $1,000, he claims that there is $4,000 in the envelope in the hotel safe but then does not let King see what is actually in the envelope until after he has

Maverick "squares off" against Phineas King, the Silver King.

folded, leaving Maverick with the night's pot. What follows is a pattern whereby King, who behaves undemocratically as an imperial ruler of the town, reacts with either physical or emotional violence, and Maverick counters this violence with his wits.

King orders Maverick roughed up to get him to leave town, and Maverick then confronts King, defining him as owning "the town, the mine, five million dollars" and claiming that in his lust for power he "cheats the way some men drink, because they have to." King answers by ordering, in a manner that allows his own plausible deniability, to have Maverick shot. King's feudal, baronial rule of the town bears more than a slight resemblance to Jack Warner's rule of his studio, and Garner was later to claim in language similar to what happened to his Bret

in the town that Warner "tried to kill my movie career" (Garner and Winokur, 68). Garner refused to cancel his lawsuit after this threat and likewise Maverick stays in the town, again using his wits to survive by taking an advertisement in the newspaper stating that "Phineas King did not make any attempt to kill me today"; indeed, "Jack Warner did not make any attempt to fire me today" may have been a sentiment that expressed the precarity that many of the creative artists experienced around Warner and his studio.

Maverick then expands the poker game to the overall economic relations in the town, forging a rival silver mining company, called New Hope, where workers are paid ten cents more an hour and work ten instead of twelve hours. He also fixes an election that has never been democratic by appealing to citizens who think they are the only ones writing in an alcoholic judge, Josh Thayler, who has resorted to the bottle because he refused to be a dishonest judge. Maverick's company prospers while mining veins on King's land. When King takes the company to court, Maverick, who views the law as a crapshoot aligned against the ordinary man but, as at the gambling table, a place where one may find an angle and perhaps for a short time quirkily outwit its propensity to back power, cites the obscure "Apex Law." This legal anomaly, never officially overturned, allows miners to pursue a silver vein even if it flows into someone else's property. King's violent reaction to the judge's ruling in favor of the New Hope miners is to flood the mines until his lawyer, Bixby, can get the law overturned at the county seat.

King, when he hears of the labor reforms by the new company, calls its improved treatment of workers "immoral" and says of the miners, in an analysis drawn almost directly from Karl Marx's description of the industrialists in *Capital,* "Working ten hours a day, you can only sleep eight hours. What will they do with the other six?" King threatens to kill Maverick if he appears to confront him and wields his pistol at a telegram delivery boy. The boy brings a message that an ally of Maverick,

29

Big Mike McComb, has altered to make it seem that King has lost the appeal. Maverick then convinces King to merge his company with New Hope, restarting work in the mines and granting the labor concessions not because he does not want "to see men out of work, families going hungry" but because he believes he has lost the case and because Maverick has humanized King, portraying him as caring to the miners who wait below to hear his answer.

In the penultimate scene King asks Maverick to stay and join him, but Maverick refuses, saying that if he stayed he might be tempted to become another Phineas King—"The bigger I'd get, the smaller the town would get and I'd like to leave it the size I found it"—in a way that echoes Huggins's own odyssey working for several studios but never owning one. King, finding that he has won the case and been tricked by Maverick, reacts by arbitrarily firing his lawyer. Admiringly King says of Maverick, now on his way out of town (or on to his next writing assignment), that he beat the capitalist owner by "guts, nothing but guts." The ending seems a kind of utopian moment of this Jack Warner prototype, acknowledging the skill of his creative personnel, but it did have its echo in reality when, after Garner beat the studio, Jack Warner is said to have tried to be enraged at Garner but then admitted that he could not stay angry at someone who was so likable (Strait).

When Maverick leaves, Big Mike follows him and says that wherever the gambler shows up will be an exciting place, and Big Mike wants to be there. This last scene is in one sense simply a reminder to tune in next week, but in terms of the allegory it does present a final contrast between the freer, and poorer, itinerant artist living by his or her creativity and the owner/magnate/studio boss exercising violent and arbitrary power in a never-ending quest to translate workers' creative energy back into an ossified capital that continues to reproduce itself in ever more stifling ways.

Riding the Revisionist Range

Maverick's Challenge to the Adult Western

M *averick* brought the spirit of the revisionist Western, which questioned the imperial, patriarchal values of the genre, to television while that change in the form was just beginning to be developed on the wide screen. The show achieved this breakthrough by positioning itself as opposite the supposedly mature adult Western or, as the writer Marion Hargrove put it, by staging "satirical guerilla raids" on "straight" Westerns (Anderson, 236). *Maverick* not only broke with but also devoted episodes to satirizing the two most popular Westerns that bracketed its run, *Gunsmoke* (1955–75) and *Bonanza* (1959– 73). The former was a *High Noon* validation of "controlled" violence used judiciously by the representative of (U.S.) law and order. The latter was a patriarchal validation of the establishment and defense of an empire of private property by a wealthy rancher whose exercise of power in the post–Civil War era was not unlike that of the U.S. imperial Pax Americana after World War II. Maverick, neither sheriff nor land baron, was more often, in his position as itinerant gambler at the edge of the

law, the kind of character *Gunsmoke*'s Marshal Dillon and the Ponderosa's Ben Cartwright would be running out of town or off his land.

The adult Western on television had evolved both from that form on the wide screen and as a (largely commercial) reaction to the kiddie Western, prevalent on television in the first half of the 1950s, with the more mature form being used to market to an older demographic. Huggins and his team of writers were able to expose these grim morality tales as far less sophisticated and as prone to slightly disguising, rather than complexifying, the often violent milieu of the Saturday matinee–like kiddie Westerns. "If the average Western is a reaction against the realities of modern life, *Maverick* is a reaction against the unrealities of the average Western," claimed Marion Hargrove (Anderson, 236). And indeed, the show opposed many of those values by focusing on a Western milieu that was more often than not an extension of the corruption of the United States as a whole in the key years of the Gilded Age, questioning the Western's fetish of violence in its focus on the gun, and using a conception of time that could expand to concentrate more on long-term effects and outcomes, as opposed to the Western's more tight focus on a unity of time and space that often precluded contemplation. Finally and most adamantly, Maverick's focus on pleasure and the pleasures of the West directly contradicted the Western Puritan-Calvinist ethos of grim, determined hard work as the measure of a man.

The end result of this reorientation of focus was, as Garner later described it, a show that was "antiestablishment" and mocked and contributed to the ultimate decline of the Warner Bros. stable of "buttoned-down" heroes with their "black-and-white-morality" (Garner and Winokur, 67). It was in this way that the "revisionist Western," a political and cultural term rather than an industrial term like "adult Western," came to television. "After *Maverick* it was hard to watch those

steely-eyed cowboys without laughing" is the way Garner expressed this break. *Maverick* parodies of *Gunsmoke* and *Bonanza* highlighted in a specific way the extent to which every week the series parodied the genre.

The Lone Ranger to the Sundance Kid:
The Western Grows Up and Then Gets Politicized

The first era of the television Western featured the hugely popular, largely syndicated, kiddie Western, an almost straight transfer from the studio B Western and one where, at the height of the Cold War (1950–55), the values were calculatedly and crassly American corporatist. The Western heroes—the Lone Ranger, Hopalong Cassidy, Gene Autry, and Roy Rogers—were all various forms of "medieval knights" bringing "law, order and justice to the frontier" (Yoggy, 6). Hopalong Cassidy's dictates to his youthful audience included "obey your parents" and "always be courteous," though Cassidy's William Boyd was best known for the millions he earned in merchandising to this same audience—$800,000 in 1950, which for that time *was* a lot of money ("William Boyd & Hopalong Cassidy").

The Lone Ranger, according to an ad agency brochure, was "motivated by love of country" and was "generally visualized as a Protestant" with his classic grim, determined Anglo-Saxon jaw behind the mask. Devoid of interest in sex, he was a model of "good citizenship and clean living," so much so that he was adopted by the Treasury Department in its Lone Ranger Peace Patrol in 1958 (Yoggy, 12–13). Gene Autry's Cowboy Code was summed up in its tenth and ultimate point: "He was a patriot" (Yoggy, 23). Roy Rogers also was no rootless wanderer (à la *Maverick*) but was instead "a prominent settled rancher," and he and his cowgirl, or rather corancher, Dale Evans specifically identified themselves as Christian (Yoggy, 34).

The shows espoused "controlled" but always necessary violence as the means of defending both the country and their own

private property. The only mild alternative to this 1950s conservative onslaught was *The Cisco Kid,* a supposedly Mexican Robin Hood of the West played by a Romanian actor, Duncan Renaldo, who had been threatened in the 1930s with deportation (Yoggy, 38), that is, being thrown out of Hopalong Cassidy's white, Anglo-Saxon, corporate, Cold War West.

The cinematic reaction to the kiddie and B Western was the A Western, that is, bigger-budget prestige Westerns in the late 1940s and early to mid-1950s that seemed to tackle more mature adult themes and appeared to be more nuanced around violence, including *Duel in the Sun* (1948), *The Gunfighter* (1950), and *High Noon* (1952). Andre Bazin called these films "Superwesterns," claiming that they "combine a story that might well have been developed in another genre with a traditional Western theme" and that the genre as a whole was now "a form in need of a content" (51).

This adult Western, though, at least when it came to television, was hardly a tabula rasa on which to imprint psychological complexity. This change in the form was defined most auspiciously not in thematic but in industry and commercial terms as a type of programming that could provide a "sophisticated environment for advertising . . . expensive obviously adult products" such as automobiles and cigarettes (Anderson, 203). John Wayne introduced the first episode of *Gunsmoke,* the prototype of this subgenre, describing the show as "honest," "adult," and "realistic." (Wayne's appraisal, though, was also a commercial endorsement, since he owned a share in the production company.) The form proved durable and very popular, with *Gunsmoke* being the number one show in the country for four seasons, 1957–61. At the height of its popularity in the 1958–59 season, for which *Maverick* won the Emmy, the genre accounted for fourteen shows, that is, almost half of the top thirty shows in the country (Edgerton, 187).[1]

The television adult Western has been described variously as blending "dramatic conflict, human insight, outdoor beauty,

and subtle moralizing" without "eliminating action" and as "grafting onto the western characters the emotions, fears, inadequacies, and psychoses of modern man" (Yoggy, 77–78). The form was seen as consisting of emotionally torn characters who, in the words of Cleveland Amory, one of the most prominent television critics of the time, were "not only good guys or bad guys but also in-between guys" (qtd. in MacDonald, *Who Shot the Sheriff?*, 51). The series were also directed by Hollywood masters of the genre, including Sam Fuller, Bud Boetticher, and Tay Garnett.

However, there were also striking similarities to the values and the production of the kiddie Western. The series were literally built one on top of the other, with, as in the case of *Maverick,* the studios often using archive footage of golden age B Westerns for the action scenes. More telling about the similarities is historian Ralph Brauer's criticism that the adult Westerns actually contained more violence and of a more deadly nature than the kiddie Westerns, since while the hero of the kiddie Western would shoot the gun out of the hand of the villain, the hero of the "mature" Western would often "kill or beat him senseless" (qtd. in Yoggy, 77). James Arness's evaluation of his marshal on *Gunsmoke* is not so far from the Lone Ranger's moral asexuality: "As a hero, I represent law and order—authority. . . . I can't go too far in romancing Kitty" (Yoggy, 93). Largely, though, rather than questioning the values of the Western, the adult Western in film and television often featured the hero who, instead of modifying his values, worked through his fear and neuroses in order to again arrive at the need for controlled violence in defense of civilization. Civilization itself was often defined in terms of property. The classic example is the final gunfight in which the sheriff in *High Noon* reluctantly engages, which protects the town's property classes and is the visual model for the opening of the television adult prototype *Gunsmoke.*[2]

Early on, Huggins had brought some of the quality of his earlier film noirs to the Western in "The Argonauts," his third

episode of *Cheyenne,* a *Treasure of Sierra Madre* (1948) tale of two miners, one of whose lust for gold results nearly in his partner's death. The change heralded by this episode was hailed by *Variety* as "astonishing," making this "the most adult of all the 'adult Westerns'" (Anderson, 206) and contributing to Huggins's subsequent independence at Warner Bros., where he would further undercut the formula. Even here, though, the dictates of the market forced a happy ending whereby the other miner turns altruistic, thus blunting the critique of the effects of greed but contributing to making the episode palatable for and ultimately flattering to an adult male consumer.

The cinematic revisionist Western was different, though. It was defined not by ambiguity and moral complexity, which often led the Western hero back to the same violent path, but by in its strongest iterations a questioning of the values of the West. As such, the term "revisionist Western" was political, not industrial. The name itself came from William Appleman Williams's concept of revisionist history, which rewrote U.S. history as a history of imperial and capitalist expansion heightened during the post–Civil War era of manifest destiny covered by the Western. Williams's reinterpretation included a designation of the Cold War as, similarly, a cover for contemporary expansion.

In the cinema, the revisionist Western is generally regarded as beginning with John Ford's *The Searchers* (1956), in which the Wayne character after a long quest for vengeance partially refuses to take it.[3] This change continued with films such as Ford's *Cheyenne Autumn* (1964), a reworking of his earlier casual cinematic slaughter of the Indians. This "revisionist shadow" running parallel to "the imperial mainstream" (Kitses, 17) becomes the mainstream Western by 1969's *Butch Cassidy and the Sundance Kid,* whose contemporary sequel *The Sting* (1973) was said to have been partially based on *Maverick.* Here fully for the first time, the "unregenerate outlaw" is presented "as a sympathetic figure," with the film "expressing a definite

sense of regret at his elimination by the agents of law and order" (Cawelti, 106).

The questioning of the values of the Western, and particularly the moral correctness of the guardians of law and order, became such a part of the genre that by 1996 Jim Kitses could claim that "no other form appears to have generated a countertradition on the Western's scale" and that this countertradition, rather than eroding the Western, "now *is* the Western" (Kitses, 21). Sergio Leone, who brought the revisionist Western to Europe, explained the rationale for his questioning of the values of the genre. Growing up, he idealized "the wide open spaces of America," but when the Americans invaded Italy in World War II, he found these armed shadows of his cowboy heroes instead "materialist, possessive, keen on pleasures and earthly goods. . . . [In them I could see] almost nothing—of the great prairies, or of the demi-gods of my childhood" (qtd. in Mitchell, 238). And thus his West is a Hobbesian dog-eat-dog world that is crassly avaricious.

The television revisionist Western begins with *Maverick* and erupts as a reaction against the adult Western. Huggins described the "fascinating sameness" of the *Gunsmoke*-era series and how he took delight in how his show "turned every cliché inside out" (Robertson, 4). He even mocked his own adult Western in creating a character who had none of *Cheyenne's* "irritating perfection" (Anderson, 230). Maverick's profession of gambler had him always straddling the law and constantly vacillating between luxurious pleasure and penury, with his motives often self-centered rather than heroic. If in the typical Western the dude gambler was a villain who dressed in black, in *Maverick* the gambler dressed in black was the hero. Few series immediately followed *Maverick's* genre busting. The opposite happened with the rise of *Bonanza* and another Huggins series, *The Virginian* (1962–71), both celebrating the imperial expanses of the West.

37

But three series in the later 1960s and early 1970s cast the disparaging shadow. The best of these was *Branded* (1965–66), with Chuck Connors as a supposed coward drummed out of the army and thus questioning his valiant former role as *The Rifleman* (1958–63).[4] Multiple episodes were directed by Robert Altman, who would later helm two cinematic Westerns— *McCabe and Mrs. Miller* (1971) and *Buffalo Bill and the Indians* (1976)—that threw the entire basis of the genre into question.[5] Another recalcitrant Western was *The Outcasts* (1968–69), which put the issue of race in the forefront with its aristocratic southern bounty hunter teamed with a former slave who had fought for the Union, a relationship that is currently being rerun in the contemporary Western *Hell on Wheels* (2011–).

Finally, another Huggins series, *Alias Smith and Jones* (1971– 73)[6]—somewhat based on *Butch Cassidy and the Sundance Kid,* as that film's sequel *The Sting,* with its two lovable grifters, had been based on *Maverick*—followed the fictionalized adventures of a real-life outlaw, Kid Curry, and his partner Hannibal Jones, granted a pardon if they can stay out of trouble for one year. This series describes, from the point of view of the outlaw and in a tone that is comic and parodic, the illegality of the sheriffs, deputies, and bounty hunters, often ex-criminals themselves, bent on tracking down the lead characters for the $10,000 reward posted on them. Kid Curry allows in an interchange that they tried to avoid "anything illegal," to which Hannibal replies with a twinkle, "Sometimes shady maybe, but never illegal" (Yoggy, 48).

Maverick as Pappy to the Revisionist Western

Maverick rewrote the adult Western and aligned itself with the then-emerging revisionist Western in a number of key areas. The series' periodization of the Western emphasized a competing view of the West not as heroic settlement but as extension of the corrupt Gilded Age while questioning the patriarchal values of the so-called property Western. *Maverick*'s elongated view of

time, unusual in the Western, was just coming into vogue in the cinema with Ford's *The Searchers,* in which Ethan Edwards exhausts his immediate thirst for revenge in a lengthy quest. There was also a focus on the West as locus of pleasure that went along with a passive view toward violence and a corresponding de-emphasis on the Western fetishes of the gun and the horse.

History and the Western

The revisionist Western was generally seen as embracing a more specifically historicized, less mythic West. The typical Western was set in the immediate post–Civil War period amid the Indian Wars, which began almost as soon as the Civil War was over, but the sense of the films was an enduring West that seemed unbounded by time.[7] *Maverick* is set in the same 1865–71 era but presents it differently than is usually portrayed. Rather than populated by stout and sturdy men and women bravely dedicated to carving out their place in this vast land, *Maverick* focuses on the West as a place of con men (and women) who survived by their wits in an era of constant speculation. (In season three's "The Sheriff of Duck 'n' Shoot," Bret survives being blackmailed into the role of sheriff by besting rowdy cowboys, only too eager to take him up on it, in cards and laying odds on their saloon brawls.) The show focuses on the West as representative of the rampant speculation (in land, money, and minerals) that characterized the 1865–71 period as the height of the Gilded Age.

In place of the "noble savage" and the stout-hearted plainsmen, this alternate view of the West was one fueled by speculators whereby the ethos was not pioneer exploration but rather the desire "to organize, and exploit the resources of a nation upon a gigantic scale . . . in the name of an uncontrolled appetite for private profit" (Josephson, viii). *Maverick*'s West is a place where, as Walt Whitman described it, almost nothing disrupted these speculators' "almost maniacal appetite for wealth" in an

39

age characterized by its "vigorous self-seeking of individual appetites" (76, 151). Mid-twentieth-century studies of the West validate this appraisal, maintaining as does Allan Bogue that "land speculation and other patterns of advanced capitalism were far more important in the development of the West than the Lone Ranger" (qtd. in Cawelti, 2). Even the idea that the West was developed in rural settlements has been challenged, with one study concluding that cities were much more important in the region's development than the wide-open spaces of the hearty plainsman or cowboy and that the pattern was often a circulation outward from the city to the countryside (3).

Maverick welcomed, nay wallowed in, this view of the West as epitomizing the speculative frenzy gripping the country. The show often lifted its plots involving "land scandals, fleecings over railroad rights and mining frauds" from its sourcebook, J. R. Weil's *Yellow Kid Weil: The Autobiography of America's Master Swindler* (1948), which detailed the conniving of a "much-loved" grifter in the Gilded Age (Strait, 82). The *Maverick* characters certainly shared this mentality, with Bret typically declaring in the episode "Duel at Sundown," where he risks being shot down in the street in a battle with a much faster gunslinger in order to collect on a bet, "Sometimes it frightens me what I'll do for money." Plots on the series most often involved Maverick winning money and then losing it to a dishonest person or crook whom he subsequently outwits, with his besting of the foe often involving a "swindle, scheme or method of cheating" (Yoggy, 237).

While wild distortions in valuing land and minerals had been prevalent in U.S. history—in 1797 the English traveler William Priest characterized the country as "the land of speculations" (Josephson, 22)—this trend reached a crescendo in the opening moment of the Gilded Age, the moment of that greatest speculative bubble of them all, the transcontinental railroad. It was a time when, as J. G. Pyle put it, "the hypothecation of the future proceeded rapidly . . . [and] built a towering pyramid

of hope" (Josephson, 162). This rage to gamble on the future made all classes into speculators. For the wealthiest, there were the railroad and stocks and bonds. Elsewhere, there was gold favored by female speculators, mining stock and petroleum for clergymen, the Erie railroad and transportation complex for lawyers, and inflated wheat prices for farmers (Josephson, 152). Never mind that this would all come cascading down between 1871 and 1873 as the Prussian War in France,[8] a crash on the Vienna exchange, and the Union-Pacific Railroad fraud resulted in a credit shortage that prompted "the greatest 'crisis' in American history" (Josephson, 170). This frenzy culminated in the extreme suffering of the winter of 1873, when ordinary speculators froze to death and entrepreneurs such as Andrew Carnegie and the railroad's Jay Gould, sensing a bargain, continued to profit by buying up underpriced companies.

This gambling on the country's resources, its "mountains of salt and iron, of lead, copper silver and gold" (Josephson, 4), was spearheaded by eastern U.S. financiers who, when they approached the wide-open West, "became half-savage in the wilderness," just as did their poorer brethren in their "rush for the gold and the town site claims" (22). Maverick's fleecings at the poker table were only the common expression of the respectable railroad builders such as Collis P. Huntington, whose Central Pacific, in an appraisal that would make even Twitter and Amazon blush, was at one point valued at $8.5 million, with not a cent paid into the company (9). All along the way, the railroad was financed by government grants with, for example, Gould's Union Pacific paid $50 million in excess of the costs of building (92).

The enterprise also included blackmailing towns into financing the construction costs because of the threat of annihilation if the railroad circumvented them. "A railway man approaches a small town as a highwayman approaches a victim" was the way one commentator described this transaction (86). The stock exchanges, where this systematized speculation was

executed, were described as the haunt of "gamblers and thieves" and their corporate offices as "secret chambers in which trustees plotted . . . spoilation" (168). Andrew Johnson, Abraham Lincoln's vice president before becoming president, declared that the next great war after the Civil War would have to be fought against the "National securities [trusts] in the Northern States" (80). Walt Whitman summed up the post–Civil War period by claiming that "the depravity of the business classes of our country is not less than had been supposed, but infinitely greater" (qtd. in Felheim, xvi).

The country's novelists were well aware of this ethos, and the conniving spirit was the subject of both Herman Melville's *The Confidence Man,* written in the pre–Civil War era when capital was just beginning to loosen its prescriptive, restraining codes (Josephson, 10), and Mark Twain's *The Gilded Age.* In Melville's tale, set just prior to the massive speculation that was to begin with the Civil War, unfaithfulness prevails in a floating hold of *connerie* aboard the *Fidèle* (French for "faithful"), a ship bound down the Mississippi whose tricksters are compared to the pilgrims in *The Canterbury Tales.* They include "Parlor men and backwoodsmen; farm-hunters, bee-hunters, happiness-hunters, truth-hunters, and still keener hunters after all these hunters" as well as "Northern speculators and Eastern philosophers" (Melville, 17). Melville's, though, is part of the prewar ethos whereby it is still possible to look askance at this activity and to be morally outraged over its pervasiveness. One con man explains how the worst liability in his profession is "compassionating," "since this might begat a habit of thinking and feeling which might unexpectedly betray him upon unsuitable occasions. Indeed . . . there was nothing which a good man was more bound to guard against than . . . the emotional unreserve of his natural heart" (82).

Twain, writing during the era, is much more imbued with its values. His is still a moral outrage, but its persistent presentation in a humorous vein is also, when compared to Melville,

a sign of his consciousness being penetrated by the spirit of the age. Twain's characters wallow in "Beautiful credit," one of them claiming that "I wasn't worth a cent two years ago, and now I owe two millions of dollars" (193). Sellers, his ultimate blowhard whose appellation "Colonel" is an inflated title and whose name suggests that everything is for sale, basks in this delusional and dishonest moment, claiming that "There is no country in the world, sir, that pursues corruption as inveterately as we do. . . . I think there is something great in being a model for the whole civilized world" (357). Finally, his hero Phillip, who does at least study engineering and finally strikes a vein of coal but at the price of nearly losing Ruth, the woman he loves, is perhaps the "normal" representative who shows how far this speculative esprit de corps has penetrated ordinary life:

43

> He was not idle or lazy, he had energy and a disposition to carve his way. But he was born into a time when all young men of his age caught the fever of speculation, and expected to get on in the world by the omission of some of the regular processes which have been appointed from of old. . . . He saw people, all around him, poor yesterday, rich today, who had come into sudden opulence by some means which they could not have classified among any of the regular occupations of life . . . [including the] railroad man, politician . . . [and] land speculator. (Twain, 249)

Maverick was a show steeped in this ethos that, like Twain's novel, took a jaundiced but humorous view of it. Huggins's Maverick fleeced cowboys with his belt trick, betting on the notches of the belt, while the real-life financier Daniel Drew was famous for his handkerchief trick in which he left behind a stock tip dropped from his hankie about a supposedly worthless company, causing speculators to rush to sell. Drew then

bought the stock sold as worthless and "gulled" (fleeced) his fellow gamblers (Josephson, 19).

The *connerie* on the show was amplified by a series of recurring charlatans, a "whole family of Mavericks" all less scrupulous than Bret and Bart. These included Dandy Jim Buckley (*77 Sunset Strip*'s eventual lead Efrem Zimbalest Jr.); Buckley's replacement, the even shadier Gentleman Jim Darby; and two female con women, the show's queen of *connerie* Samantha Crawford (Diane Brewster, who would cameo later as Richard Kimble's murdered wife in *The Fugitive*) and the phony southern belle Cindy Lou Brown.

The heart of the series was the brothers' involvement in typical Gilded Age swindles. "The Comstock Conspiracy" involved Bret in the shady dealings around the Comstock mines in Virginia City. "Shady Deal at Sunny Acres" (discussed in detail in chapter 3) concerned fraud by a bank president who takes Bret's money after hours and swears the next day that Bret never made a deposit. "Two Beggars on Horseback" has the brothers each bilked out of $10,000 by the Gannet Express Company's bankruptcy and in a race with each other to see who can reach the outlying office to collect the last $10,000 before the office knows the company is defunct. Finally, "The Brasada Spur" has Bart tricked into managing a railroad line that has practically ceased to function, left for dead like the towns the railroad blackmailed.

Bret Maverick, as Huggins described him, was a "situational ethicist" (Roberston, 243) imbued with the spirit of the Gilded Age when, as Twain wrote, "If great wealth acquired by conspicuous ingenuity . . . [had] just a pleasant little spice of illegality about it, all the better" (230). Likewise, Melville's description by one of the con man's marks of the type of person admired in that age fit as well Huggins's "gentle grafter": "I like prosperous fellows, comfortable fellows; fellows that talk comfortably and prosperously, like you. Such fellows are generally honest" (Melville, 64).

Time and the Western

The television adult Western, as is typical in male action genres, often concentrated and ultimately fetishized time. Aristotle's unity of time and place, that the action be compressed as much as possible into a twenty-four-hour period in the same locale, when applied to the Western was used in the genre to amplify the violent content of the form. The compressed time scheme often consisted of an original violent act, the readying of the protagonist for an equally violent retaliation for the action, and the final gunfight, an eruption of violence that "solves" the problem. *High Noon,* the epitome of the adult Western whose opening is quoted in the opening of the first television adult Western *Gunsmoke,* reflexively highlights this compression by having its gun duel take place in "real" time (Combs).[9] Thomas Elsaesser in "Tales of Sound and Fury" points out that in contrast to the male action genres, the more female-oriented melodrama instead often expands rather than compresses time so that its characters develop over time, as do the two daughters in *Imitation of Life* (1959), to allow the audience to experience the long-term consequences of character actions.

Maverick, at least in the first season, alternated between the concentrated and expanded view of time, and two episodes in particular were built on the extended view. "The Wrecker," based on a short story by Robert Louis Stevenson, begins in New Orleans and involves Bart taking a place aboard a ship bound to locate a beached frigate, *The Flying Scud,* with the ship's first mate Paul Carthew, whose mutinous secret involved stopping the frigate's captain from importing opium and is finally revealed after many months and some seasickness. In "The Long Hunt," Bret is saved by a robber, Lefty Dolan, who is then himself gunned down but not before telling Bret that an innocent man has been convicted for a crime he committed. The path is a long and winding one before Bret finally tracks down one of the other robbers and, just before the robber dies,

forces him to clear the convicted man. Bret persists in this quest because he is haunted by "the ghost of Lefty Dolan." In the end he says, in voice-over, that the journey had "taken a year out of my life off and on but now it finally seemed worth it," mainly because the wife of the convicted man now can start over. The voice-over and extended duration of the narrative allow a more subtle development of a story of justice as taking place over time that is the antithesis of the ticking time bomb of the usual Western plot and that de-emphasizes the intensified building of the narrative to a violent conclusion fueled by immediate revenge rather than by protracted reflection.

Pleasure and the Western

46

Raymond Durgnat claimed that the Western hero was guided by a grim puritanism, which valued inner direction and solitude, combined with a Calvinism in which "pleasure causes death" (70). This hero was tight-lipped, though his limited speech was poignant and profound. His constant companion was his horse. At home in the vast vistas of the wide-open Western space, these heroes looked "as if they just stepped out of a painting by Frederick Remington" (Yoggy, 252).

In contrast, Maverick's natural habitat was the saloon. Rather than the expansive vistas, he enjoyed the good hotels, fine clothes (his trademark was the vest rather than the rough shirt and chaps of the wrangler), and what elegant living he could afford. He was garrulous instead of laconic, enjoying besting his opponents in verbal rather than physical duels, and he often spoke not because he had the exact right thing to say but rather to hear himself speak. His disdain for the iconography of the West—he looked more like he stepped out of one of Toulouse Lautrec's demimonde cafés than Remington's western plains—can be seen in his view of his horse. The classical Western director Budd Boetticher suggested to Huggins that Maverick should have a trademark horse, as did Randolph Scott in

Maverick and his "horse" in "Relic of Fort Tejon."

Boetticher's series. Huggins replied, "Maverick would sell his horse in a minute if he needed a stake in a poker game" (Robertson, 21). In the seventh episode, "Relic of Fort Tejon," came Huggins's narrative reply to Boetticher's suggestion, as Bret wins a steed that is the opposite of Roy Rogers's Trigger, a double-backed camel named Fatima that not only follows him across the plains but also seems to have fallen in love with him.

Patriarchy, Property, and the Western

Maverick's celebration of pleasure for its own sake in the Calvinist, puritanical West also put the show at loggerheads with another branch of the Western that came to be known as the property Western, most strongly exemplified by the series *Bonanza*. These shows were based either on a family usually organized under a strong patriarch or on a domineering owner (Dale

Robertson's railroad magnate in *The Iron Horse,* 1966–68) and centered on the protection of private wealth.[10] *Bonanza* opened with a map of the Nevada ranch the Ponderosa stressing the dominant location in the state of this vast empire, bordering, as the show's publicity material described it, Lake Tahoe, timber forests on the west, the state's commercial and mining centers of Carson City on the north, and Virginia City on the northwest (Yoggy, 296). The map then ignites in a fiery blaze, and the four Cartwrights, Ben and his three sons, ride out of it, gazing across this private wealth. The goal of the series, as the oldest son Adam states in regard to this empire, is "to keep it in Cartwright hands." Those without property were uninvited, told to keep away from "the most important single home in television" (Yoggy, 294–95); as the youngest Little Joe tells a squatter, "Next time, you go around. You hear?"

The wealth and power were emphasized also by this being the first color Western. Its studio sponsor Paramount, which had a reputation for lush scenery in the classic studio era, transferred to the small screen glimpses of the standard outdoor expanses of the A Western; its increased production values mocking Warner Bros.'s single Western street and blatant use of archive footage. The economic power of the ranch, transmuted to the small screen by its visual splendor, translated into an imperious ruling style not only on the ranch but also in the nearest town, Virginia City. The town's Sheriff Coffee was always beholden to Ben, consulting him on what course of action to take, and the Cartwrights often threatened the citizenry, though usually for a righteous cause. In "The Fear Merchants," Ben, defending the Chinese in the town most likely because he benefits from their low-wage labor, as he did with his cook Hop Sing, tells the local lumpen (propertyless) riffraff, "If any of you boys had anything to do with beating my cook, I'll tie a rope around you and drag you up and down main street."

Maverick, of course, is exactly, in Cartwright terms, the aimless drifter the family would want neither on their land nor

in their town. The Maverick family, or extended family, was made up of con men and women brought together by their larcenous nature and their attempts to bilk the "respectable" propertied classes. In its lack of traditional bonds, these relationships resembled more what Sylvia Harvey has termed "the absent family of film noir."

Far from idealizing wealth and property for its own sake—the worst criminal in the West was not the murderer but the "rustler" or "horse thief" (Durgnat, 73)—the brothers, because of the nature of the life of a gambler, were forced to display a constant easy come, easy go attitude toward their pursuit of money, which consistently seemed to be always within their grasp and then eluding them. Rather than being entirely centered around masculine power, as was *Bonanza* with the three dead mothers of each of the three sons haunting the ranch, *Maverick*'s con women, Samantha Crawford and Cindy Lou Brown, were as equally daunting and conniving as the men and were not thought of as evil, or any more evil than the men, for displaying that power.

The season five *Maverick* parody of *Bonanza,* "Three Queens Full," called attention to the female absence in the series by being focalized not around the Cartwrights but around three female scammers posing as "respectable" brides for the brothers.[11] The parody also questions the basis for the property Western, revealing that Pa Wheelwright obtained the Subrosa Ranch by swindling the Indians and that the famed Wheelwright loyalty is driven by the need to protect this secret. The show has great fun mocking the Wheelwright arrogance and power. Bart, whom the family initially wants to get rid of, is told that he is subject to a new loitering law, just passed by the town council. "Who's the council?" he asks, to which the sheriff replies, "Uh, there are seven members: Mr. Wheelwright, his three sons, foreman of his ranch, [and] his cousins." Finally appraised of the plot of the three "brides," Pa Wheelwright says they needn't be afraid: "Joe Wheelwright is always reasonable. I'll throttle the man that denies it."

Violence and the Western

Violence, its use and misuse, was a crucial component of the Western, and the supposedly mature adult Western promoted and rationalized violence exercised by the lawman or quasi lawman and fetishized his "best friend," the gun. In validating the actions of one of the first of the violent lawmen, Wyatt Earp, the actor who played him, Hugh O'Brien, claimed, seemingly unaware of how revelatory his statement was, that "Earp was a thoroughly honest man, righteous, utterly fearless. He was just—in 200 gunfights" (Yoggy, 134). Compared to this omnipresent aggression, Maverick's motto "He who fights and runs away lives to run another day" and his disdain for gunfights made him the television Western's first pacifist—and one of its only pacifists.

The development of the Colt revolver was a crucial technology in the conquest of the West, making possible the "American assault on the great plains" by being employed to best the Native American's mobility and skill with a bow and arrow (Cawelti, 86). The television Western celebrated the rifle and the revolver in all their forms, ignoring the historical use to which this murderous and genocidal technology was put and instead concentrating on individualizing each of the members of the law by their own personalized weaponry.

Wyatt Earp employed a customized handgun with a sixteen-inch barrel. Bounty hunter Josh Randall in *Wanted Dead or Alive* (1958–61) used a sawed-off pump-action .44-caliber rifle, which he claimed kicked with the power of a "mare's leg" (Yoggy, 256),[12] while his fellow bounty hunter Johnny Yuma in *The Rebel* (1959–61) sawed off the barrel of a Winchester rifle to make it handle like a revolver. *Maverick's* creators were not impervious to this fetish. The Huggins series *Colt .45* celebrated the original weapon so openly that the show's sponsors were upset that it was an unpaid advertisement for the company, and *Yancy Derringer* (1958–59), on which Huggins's successor on

Maverick Coles Trapnell had worked, was a series whose lead character's name was synonymous with the weapon he employed as a New Orleans special agent. This most dangerous branch of "product placement" was celebrated in a *TV Guide* article titled "Arms of the Western Man," and the combination of the television series and the publicity spurred an increase in Western-type gun sales by 1958 to ten thousand guns per month (MacDonald, *Who Shot the Sheriff?*, 73).

The openings of many of the shows highlighted the violence that was to come. *Gunsmoke*'s Matt Dillon drew and fired rapidly at an unknown opponent, *Wichita Town*'s (1959–60) Marshal Mike Dunbar's office window was shattered each week by three bullets, and *The Rifleman*'s (1958–63) Lucas McCain drew and fired a dozen rifle shots in rapid succession. In addition, many of the shows, such as Warner Bros.'s *Lawman* (1958–62), which opened with the Laramie marshal striding toward the camera and firing six shots in rapid succession, as well as *Wyatt Earp* (1955–61) and the early seasons of *Gunsmoke* followed the half-hour format, meaning that the typical buildup to the legitimized violence of the lawman was shorter and more compact than in an hour format, where more character development prevailed. Lee Mitchell claims that in the cinematic Western, the hesitation around the final gun battle was less "to encourage the impulse toward pacifism than to grant time to savor the imminence of violence that everyone knows will come" (248). The television Western, which had to concentrate on maintaining its audience, shortened even this delayed gratification.

Huggins and Garner had a strong predilection for avoiding violence not only in *Maverick* but also when they later teamed up in *The Rockford Files,* in which Garner's detective owned a gun but kept it at home in a cookie jar because, as Rockford claimed, "If I carry a gun, I may have to shoot somebody." Both Maverick brothers expressed their disinterest in besting their opponents through violence. Bart claimed that "My brother Bret can outdraw me any

51

day of the week, and he's known as the Second Slowest Gun in the West," and Bret acknowledged that he was "not too good with a gun" but that "I like to think the next man is worse."

The Mavericks also most often shunned the typical excuse for violence in the West: righteous revenge. The season one episode "A Rage for Vengeance" does center on settling accounts not by Bret but instead by a woman with whom he falls in love. Her quest to expose a "respectable" candidate for Montana governor as the murderer of her husband leads to her demise, and Bret does in the end best the man who ordered her death. But even here the episode instead centers around Bret robbing a bank, rather than engaging in an ultimate gun duel, to steal the counterfeit currency the woman had used to open a newspaper to crusade against the murderous political candidate. The audience satisfaction is in the revelation of why Maverick robbed a bank, not in his extracting the "vengeance" of the title.

Much more pointedly against the violent Western protagonist was "The Saga of Waco Williams," the series' most popular episode with a 51 percent share of all viewers (discussed more fully in chapter 4). Huggins satirized his other series in this episode in his use of *Colt .45*'s Wade Preston as an errant gunslinger who always takes the violent path. Bret urges that Waco Williams, rather than being confrontational, instead, like pine trees in a hurricane, "give with the wind." To this Waco replies, as he continues his aggressive pursuit of the outlaw Blackie Dolan, "That sounds like pretty good advice—for trees." In the end, as in the typical Western, Waco's violent ways are rewarded, and he finishes with the affection of the townspeople, the love of a townswoman, and the potential inheritance of a sizable ranch. In contrast, the pacifist Maverick, on his way out of the town alone and unnoticed, stops his horse, looks into the camera addressing the audience directly, and asks, in a way that called attention to how much the show bucked and thwarted the satisfactions of the typical Western and how alone it was in doing this, "Could I be wrong?"[13]

"There's a Heap o' Trouble, Mr. Dillon"

The notorious opening of "Gun-Shy," the *Maverick* parody of *Gunsmoke,* stressed neither the marshal's prowess with his six-shooter nor his steadfastness in facing down an opponent. Instead, the low-angle rear-view shot focused on Dillon's derrière, showing him to be, to literalize the visual pun, not the fastest gun but the biggest ass in the West.[14] The episode followed suit, treating the esteemed marshal as a violent simpleton whose outward bluster masked an inner insecurity. By distinguishing itself so sharply from what was then the top-rated Western, *Maverick,* in all the ways that we have discussed, accentuated its revisionist break from the adult Western.

Matt Dillon, the righteous marshal of Dodge City, Kansas, was a beloved and seemingly benevolent figure on American television. Dillon was presented as a model of

Maverick facing off against Marshal Dooley's derrière in the *Gunsmoke* parody "Gun Shy."

restraint compared to the bad men he encountered, waiting to draw his gun and shoot down Pernell Roberts (soon to be Adam in *Bonanza*) as a seemingly random female murderer in "How to Kill a Woman." Dillon was surrounded by town notables Miss Kitty, co-owner with Dillon of the saloon; Doc Adams; and Dillon's assistant Chester, the lovable cripple (never deputized, so in effect a vigilante).[15] Clearly, Maverick was cut from different cloth. The episode's writer Marion Hargrove described *Gunsmoke* as the "solid, solemn daddy" of all TV Westerns and argued that his parody exposed "the violent, formulaic Western hidden behind the grave façade" (Anderson, 236). Following the *Maverick* episode, there was a discussion on the *Gunsmoke* set about an episode centered around a blaggard named Huggins, but the episode never happened, and Hargrove pointed to the way that the moral tone exercised by *Gunsmoke,* the genre dominant, would not allow satire: "*Gunsmoke* . . . cannot parody *Maverick* without endangering its own impressive dignity, and *Maverick* has no dignity to attack" (Anderson, 236).

Primarily, the parody mocks and exposes Dillon's violent nature. The episode opens with Marshal Mort Dooley in voice-over at the cemetery at Boot Hill reminiscing about those he killed and anticipating those he will soon kill, "maybe getting ahead a grave or two" (a reference to an actual episode "Mail Order Bride" that begins in the same location, with Dillon in voice-over looking over the graves and boasting that "a few of these I had a part in"). His arbitrary misuse of power is stressed when upon first seeing Maverick, he threatens to run him out of town for "flaunting authority and goading me into a gunfight." Dooley's predilection for violence is emphasized later when, upon finding the town street excavated (by two swindlers hunting Confederate gold), he blames the hole erroneously on the town's youths getting "meaner every day" and "you parents for not taking a stick to 'em."

Doc Stucke asks Dooley how many men he has shot this month for "aggravating him a lot less" than Maverick. Dooley tries to count the number on his fingers, realizes he can't, and then says "eleven." Violence is often a cover for the lawman's stupidity, as the marshal, when asked what he will do when he faces a threat from Indians as part of a hoax Maverick has perpetrated to get him out of town, says blankly, "I'll know when I get there." Later the Indians mock him as he approaches them with upraised hand and his greeting "How," to which they, being more cosmopolitan and revealing themselves to be merchants selling blankets, answer "Can't complain, Marshal. How you?"[16]

The duel scene, with its infamous low-angle rear view of the marshal, has him firing rapidly at Maverick, as was his wont on the show, with Maverick a speck in the background. Again, the ignorance of settling arguments with violence is exposed as Dooley misses and Maverick shouts, "Should I stand a little closer, Marshal?" Dooley responds by citing the code of honor of the West: "Use your gun." To this Maverick replies, "What's the point of that? I'm just as far out of range as you are." The marshal's failure in the duel is followed by his lapsing into a depression, indicating the place of violence in his self-esteem and, as much as was possible in 1950s television, stressing that his prowess with the gun had been a compensation and a sublimation of his sexual drive in not "going too far in romancing Kitty." It is Maverick who finally restores the marshal's confidence by feigning his fear of the marshal and galloping out of town, with the marshal, his false bluster restored, intoning in voice-over, "That tinhorn was as yellow as the rest of them."

A second critique of the show focuses on the marshal's economic position in the town. Though he presents himself as an impartial force of law and order, in the show he did actually own part of the saloon, and so his protecting the town and policing the saloon also was a part of protecting his

investment. The parody has Dooley's voice-over continually emphasizing his majority ownership of the town's most visible profit center. "I'm a merchant myself; I own 37 and a half percent of the Weeping Willow Saloon" is his constant boast, comparing his proportion to Amy (Kitty) "who owns 27 percent," Clyde "who owns 37 percent," and Doc "who owns 17 percent." Thus, in this not so far from the truth parable of the Gilded Age, Dooley is surrounded not by friends but by investors. Twice in escorting Maverick on a stage out of the town he tells him to wait for the "decent element" to disembark, and twice exiting the stage are con men who, like Maverick, have come to Elwood to search for lost gold. The marshal says erroneously about the thieves that "I know a respectable businessman when I see one," his ignorance also suggesting that in this age the respectable businessman and the thief were one and the same.

The show also contrasts the more liberated view of femininity on *Maverick* with *Gunsmoke*'s patriarchal view. Miss Amy's only line is a constantly implored "Mort, be careful," no matter what the marshal does or where he is going. The show alternately presents one of its con women, Helen, who poses initially as a reporter to find out what Maverick and one of the charlatans, Hawkins, are up to. When she is caught by Bret, she cleverly trips him and escapes. The *Maverick* female con women were a new kind of character in the Western, every bit the equal of the con men, and rather than being confined to the saloon as showgirls, to the home as ranchers' wives, or the schoolroom as the town teacher, they were instead often unscrupulously straddling the law, equally often besting the Mavericks at their own game, and enjoying the same freedom of movement throughout the West as the two gamblers.[17]

The show's most effective criticism, though, involved its intricate shift of focalization. It begins with Dooley's narration in his town and his introduction of his compatriots, but the emphasis begins to shift when, in a conversation

between Doc and Dooley about rustlers, Maverick's voice-over intervenes to proclaim that this is a show about more sophisticated chicanery and not the standard Western: "I hate to butt into the marshal's story like this, but somebody has to tell you. The conversation you just heard has nothing to do with this story, and there will be no further reference to rustling." Shortly after, Dooley's voice-over about never knowing "where you're going to be sent next and by whom" as he rides out of town is followed by a camera movement sweeping the opposite direction, revealing Maverick, who has sent him on this fake mission, shaking his head at the marshal's foolishness. This shot reasserts Maverick's place as central focus and organizer of the marshal's narrative.[18]

The story concludes not with the *Gunsmoke* adult Western battle in the street but instead with Maverick in the street at night digging up what should be the Confederate gold, only to find that it is worthless Confederate certificates. The Maverick plot and conflict are not solved by violent ends. A coda returns the narration to Dooley, who supposedly scares Maverick into leaving town and then has his "dignity" restored. However, the audience is left not with Dooley's narration but with Maverick explaining his feigning fright for the purpose of doing his "little bit for law and order in the West" in restoring the marshal's fractured masculinity.

The final line of the episode points to a crucial distinction between the protagonists of the two series. Hawkins, the English con man and a bit of a Dickensian Mr. Micawber, chides Maverick for being "too sentimental." And indeed, in the episode and as is often the case in the series, Maverick registers compassion for Helen when he returns to tell her that her dead father was not a thief. He reacts equally compassionately in helping to restore Dooley's fractured masculinity, though Dooley only treated him harshly. Maverick's empathy and his morality, even though often contingent in an amoral world, contrast sharply with Dillon's cruelty in the *Gunsmoke* series, often disguised

as a reasonable preoccupation with male codes of bonding. At the end of the "How to Kill a Woman" episode, Dillon leaves a way station attendant, whom a highwayman has shot out of revenge, alone to die, returning later to gaze at his corpse and hollowly intoning, "His luck ran all the way out this morning." Maverick's situational ethics allowed for far more human feeling than Dillon's moralistic neglect.

A Dandy in Abilene

Maverick as Flâneur, Situationist, and Beat

> "As my old Pappy used to say, 'Work is fine for killin' time but it's a shaky way to make a living.'"
>
> *Bret Maverick*

Besides reacting against the standard television Western, *Maverick* was also a series that brought together countercultural trends prominent in the late 1950s in anticipation of the more widespread cultural upheaval of the 1960s. Garner himself referred to the series as "anti-establishment" (Garner and Winokur, 67), and Maverick has been called television's first antihero. An examination of these trends define and historicize the more vague label of the antihero, in this case combining three moments: one contemporary to the narrative time of the series and the other two to the time of its production.

Maverick can be thought of as a kind of Western flâneur, Charles Baudelaire's Parisian wanderer who was a combination aristocrat and bohemian and whose legacy was just being adopted in the United States. In the West this

character went by the name of "dandy." The flâneur's "work" was a kind of detached observation and a creation of himself as urban personality. This can be seen in Maverick's constant desire to not become involved and in Garner's disdain for "acting" and his essentially playing himself.

Following partially from critiques such as Paul Lafargue's *The Right to Be Lazy,* Guy Debord and the situationists in Paris at the time of Maverick's creation employed the "combined power of a critique of both wage labor and of everyday life expressed in acts" to create *situations,* "temporary, singular unities of space and time" that disrupted the capitalist flow of production (Wark, 3, 4). Maverick's disdain for traditional work, or wage labor, and his embracing of pleasure had much in common with the situationist's eruptions. In one sense the brothers' continual staging of elaborate scams, often to call attention to the unethical behavior of the powerful, were their own *situations.* The most complex of these is detailed in this chapter's concluding section on the episode "Shady Deal at Sunny Acres."

Finally, the show embraced in a more commercial setting something of the ethos of the beats. Jack Kerouac had termed the beats in the early 1950s "solitary Bartlebies" (Charters, xxix), referring to Melville's Bartleby who refused to work, but after the Korean War, around the time of the conception of the series, Kerouac claimed that a whole generation had "picked up the gestures and style and soon it was everywhere" (Charters, xxx). Garner himself prior to accepting the role lived a proto-beat lifestyle. In the same way Maverick, an itinerant drifter whom Huggins described as leaning toward "indolence" and a figure who never achieved "maturity" in "a regeneration story where the regeneration has been indefinitely postponed" (Robertson, 26), was a kind of mainstream Kerouac, on the road from, as the *Maverick* theme put it, "Natchez to New Orleans."

Strolling on the Boulevards of Biloxi:
Maverick as Flâneur

> "There is no more exquisite art than the art of wasting one's time. . . . But it is a dying art nowadays."
>
> *Bart to a woman he is setting out to con in "Diamond in the Rough"*

The flâneur was a detached urban figure, the master of both observation and the superficial in dress and gesture and of a devotion to a kind of grand leisure even though he or she (there were flâneuses also) seldom had the funds to support this lack of activity. This character was most elegiacally described in the 1860s by Charles Baudelaire in his essay "The Painter and the Modern World" as a figure whose time was passing. This rapidly disappearing stroller along the stridently gentrifying boulevards of Georges-Eugène Haussmann's Paris during the Second Empire, whose realm was "the ephemeral, the fugitive, the contingent" (Baudelaire, 13), exhibited "a subtle understanding of the entire moral mechanism of the world" and a "horror of blasé people" (9). He seemed to have no goal other than "the perpetual pursuit of happiness," and his "solitary profession is elegance" (26). This description corresponds closely to Maverick's overall demeanor and dress.

Although the flâneur's appearance and attitude—his "lightness of step, social aplomb, the simplicity in his air of authority, his way of wearing a coat or riding a horse"—marked him as an aristocrat, he was often a penniless aristocrat whose authority derived from his elegance, not from his social position (Baudelaire, 29). He was "a rich man perhaps but more likely an out-of-work Hercules" who made his living with his pen, transcribing his observations for the popular press or in the various prose descriptions or physiologies, as the genre was called, of modern life. It is this penury perhaps that accounted for the fact that his "body attitudes"—"always relaxed"—also "betray

an inner energy." Amid the corrupt splendor of Napolean III's and Baron Haussmann's Paris as speculative real estate bubble, the flâneur's grace under pressure was "the last spark of heroism within decadence" (Baudelaire, 28).

Baudelaire described the flâneur as rising above a moment when capital was turning each against the other. As Walter Benjamin noted, social relations beginning in the era just before Napoleon III's Second Empire were changing such that "People knew one another as debtors and creditors, salesmen and customers, employers and employees, and above all as competitors" (39). This description characterizes the changes wrought by the Gilded Age as well, and the character of Maverick, who considers everyone a rival in the great poker game of life, is at the same time both the epitome and the antithesis of this attitude. Bret and Bart's constant search for a poker game and constant scams aptly described the perpetual speculation that was consuming both America and France in the global capitalist moment of the Gilded Age and the Second Empire. In that sense *Maverick* maps the inner spirit of his era,[1] but as with the flâneur, the Maverick brothers' dandyism and grace under pressure, their ability to pull off the small con, was rapidly disappearing, being subsumed under the major cons of the railroad financiers, bankers, and land developers.

The brothers' protoaristocratic attitude of standoffishness and their veneration of pleasure amid lethargy, which challenged the Calvinist doctrine that leisure time is sin, was in the American context a remnant of a now displaced southern tradition. That tradition, as it reappeared in the West after the Civil War, unmoored from its roots on the slave plantations (Cawelti, 36), functioned as a critique of the ethos of the rapidly capitalizing Northeast. Edgar Allan Poe, whose "Man in the Crowd" described the London urban gentleman in a way that not only inspired Baudelaire's creation of the flâneur but also appealed to American audiences, wrote that story just after having completed "The Fall

of the House of Usher," which is replete with nostalgia for a decaying southern nobility.

There was a flâneur tradition in the United States as far back as the New York periodicals of the 1840s, when that city was described in articles such as "The Leisure Hunter" as "the place money is spent most freely for pleasure" and a city that was "destined to become the metropolis of Dandies" (Brand, 76–77). However, the character could never be presented for American audiences as simply an idler. Instead, Huggins rationalized the pursuit of leisure as a by-product of the lifestyle of a gambler, and there is precedence for this because Poe also had compared the gambler and the flâneur. The flâneur was the master of superficial observation as the gambler also needed to be, and Poe in "Man in the Crowd" noted how the gambler, like the flâneur, must during each hand "read" the "countenance," the "air and changes in facial expression of his opponents" (qtd. in Brand, 95) in order to triumph in the game. The gambler's observation in the service of winning the pot is similar to the flâneur turning his observations into articles in the popular press. This imperative to turn reflection into a means of financial survival may account for Baudelaire's description of the feverish "inner energy" that lurks just under the calm surface.

Nevertheless, as Huggins put it, Maverick's "essential indolence" and his activities, which were "seldom grandiose" (Robertson, 26), functioned, as Benjamin describes Baudelaire's flâneur, as "a protest against the division of labour which makes people into specialists . . . [and also a] protest against their industriousness" (54). Maverick does not belong in any sense to the era of the railroad and seldom rode this symbol of the dominance and corruption of the Gilded Age. His epoch is instead that of the stagecoach and more optimally of the steamboat, since it also included a gambling den, an advantage that induces Bret in "The Cruise of the Cynthia B" to purchase a dilapidated vessel. His continual scams, which were effected on the narrowest of margins, betrayed in the wit in which they were

carried out two final characteristics of Baudelaire's flâneur: his "joy of astonishing others, and the proud satisfaction of never oneself being astonished" (28), and the fact that it "matters little that the artifice and trickery are known to all, so long as their success is assured and their effect always irresistible" (33).

There is also an extratextual appropriation of the flâneur, and this can be seen in Garner's attitude toward the craft, the "work" of acting. He opposed it and spoke at length about how acting for him was natural, not to be worked at, describing himself as stumbling into the career on a whim by driving into the parking lot of a friend who happened to be an agent. At the time of the series' launching, Garner said about acting that "I enjoy it and it is a way of making a good living but the acting bug never bit me. . . . I'd like to be a retired millionaire" (Strait, 94). Huggins validated this claim. "Jim couldn't play leading men or heavies or anything that required that kind of dramatic training. . . . [It] wasn't in his genes . . . and I doubt he would have been right for those roles even if he had the training," but "dry throwaway humor was Jim Garner kind of humor" (Strait, 31).

Garner had a relaxed, leisurely attitude toward the "craft," the attitude of the flâneur, that projected well on the small screen. His secret, like that of the flâneur, was not to take himself too seriously. "I am not interested in psychoanalysis or delving deeply into hidden facets of a character . . . to be overly intense and analytical robs acting of its naturalness" (Strait, 108). "I play Jim Garner—whatever that is" (Strait, 102). True to form, he listed "Shady Deal at Sunny Acres," in which he spends most of his time sitting idly on a chair whittling, as "my favorite episode" (Garner and Winokur, 6).

Finally, women did not fare well under the sign of the flâneur, which was mainly a discourse about the freedom of bourgeois men "to explore urban zones of pleasure," including "the restaurant, the theater, the café and the brothel" (Wilson, 3), with the women discussed by Baudelaire mostly some variety of kept woman. However, he did describe the flâneuse in his "Eloge

Maverick being conned at the poker table by Samantha Crawford (Diane Brewster), the most prominent of the series flâneuses, in "According to Hoyle."

de maquillage" (Ode to Makeup) as reforming nature, which through costume and accessories was "vitalized and animated by the beautiful women who wore them" (33). *Maverick*'s stunningly attired flâneuses, such as season three's Modesty Blaine, did effect a good deal of freedom to roam, stroll, and fleece that was equal to the brothers themselves. In the episode "The Cruise of the Cynthia B," Modesty shares the boat with Bret and in the end also recoups her investment along with him. *Maverick* may in fact be the first feminist presentation of the flâneuse.

Maverick and the Virtues of Laziness: *Dérives, Détournement,* and Debordian Situations

> "Early to bed and early to rise is the curse of the working classes."
> *"The Rivals"*

If Maverick exhibited characteristics of a Western dawdler, or flâneur, the brothers also professed repeatedly their revulsion of work and their love of wandering, of play, and of arranging scams or situations that linked them to a philosophical history of questioning capitalist wage labor in works such as Paul

Lafargue's manifesto *The Right to Be Lazy* and in Guy Debord and the situationists' attempt at emancipation from the contemporary binding of workers to the consumerist spectacle.

Lafargue in the nineteenth century, following his father-in-law Karl Marx, argued that at the time of the industrial revolution the European bourgeoisie appropriated the philosophy of the clergy, "which teaches man that he is here below to suffer, and not that other philosophy which on the contrary bids man to enjoy" (Preface, 1). The American incarnation was the Calvinist spirit that sanctioned all forms of competition and urged everyone to embrace the "high seriousness" of business "as itself a kind of religion" while "holding idleness unlawful" (Josephson, 7–8). Against this principle, which he claimed the workers themselves had now embraced in their clamoring for the "Right to Work," Lafargue cited in his history of productive idleness the Spaniards and Greeks who long had hated ordinary labor and the Roman Cicero's pronouncement "What can commerce produce in the way of honor?" (Appendix, 2). Lafargue instead championed the "Right of Laziness," "mother of the arts and noble virtues" (Chapter 4, 5), and proclaimed his utopian vision in which workers worked "but three hours a day, reserving the rest of the day and night for leisure and feasting" (Chapter 2, 7). Maverick is an embodiment of these principles in his utter avoidance of "productive" labor whereby his gambler's life of itinerant card playing guarantees him the time and the means to pursue a life of pleasurable leisure.

In contesting the rapidly and rabidly evolving consumerist culture in France of the 1950s, Guy Debord and the situationists returned to Lafargue's criticism. Debord identified his first major piece of writing as a three-word slice of graffiti, "Ne travaillez jamais," translated as "Never work" (Wark, 25). The country's industrial productivity grew faster than anywhere else in the world from 1953 to 1957 and included the introduction into French society of washing machines, television sets, high-rise housing, and a doubling of spending on household

appliances. Paris itself was being remade as part of this "thoroughgoing restructuring of French life" (Jappe, 52–53), fast losing its status as a haven for alternative lifestyles. It was to this transformation that Debord and the group of primarily poets known as letterists he initially attached himself to were responding.

The letterists proposed a "conscious construction of new affective states" based on pursuit of the city as a place to reclaim "adventure, passion and play" (Jappe, 54–55). Their response to the changes that provoked in them "anger and disgust" was nevertheless "more and more . . . to find . . . [them] amusing" (Jappe, 94). Huggins had described the Maverick character as also positioned against the rigidity of behavior that 1950s American consumer culture likewise prescribed. Claiming that "We'd become a nation of security-seeking, contented conformists," Huggins nevertheless argued that "Inside every conforming American there is a rugged individualist trying to get out, and Maverick aims to help him do it" (Robertson, 43). The show itself often rebuked this conformity with humor.

The letterists had proposed recalibrating the cultural landscape through a "calculated drifting" (or *dérive*) through the consumerist city (Jappe, 59), with themselves becoming adventurers who sought to remake this urban life as a place for "play, love," and "new passions" (Wark, 217).[2] Debord's quest began with a "psychogeography"—that is, both a subjective and an objective ethnography—of a group of delinquents gathered around the grounds of Paris's Saint-Germain church, whom he argued had carved out an alternate space within commodity culture. He was in search, he claimed, not of the Gramscian organic intellectual of the working classes but of "the alcoholic intellectuals of the nonworking classes" (Wark, 17), whom he felt might show the way to a more authentic position for the proletariat in whose revolutionary mission he still believed. Debord described his entire project, based on this initial encounter, as being "to discover how to live the days that came after in a manner worthy of such a fine

beginning. You want to prolong that first experience of illegality for ever after" (Jaffe, 45).

His defense of the nature of discovery that inspired the *dérive* was that "We did not seek the formula for changing the world in books, but by wandering" (Jappe, 45). Maverick equally was a wanderer, a frequenter of saloons, often on the borderline of legal and illegal and in trouble with the law because of his shady profession. Like the letterists and situationists, his drifting through the West was not aimless. As Huggins says in his ten-point guide, "he always had an object in view; his pocket and yours. However, there are times when he is merely fleeing from heroic enterprise" (Robertson, 26). Maverick's *dérive* could also be sedentary, and it corresponded with Garner's lackadaisical approach to acting in the way that he claimed, regarding "Shady Deal at Sunny Acres," he chose to play the brother who sits on the porch whittling and observing because at that point in the season he felt tired and overworked.

The *dérive* was an attempt to remake the city from within, and this principle Debord, the letterists, and the situationists extended to art and to their writing in general through the tactic of *détournement,* which translates as "to detour, hijack, or lead astray" and was used in a way that literally meant to alter key words in literary appropriations and figuratively meant redeploying the products of the bourgeois civilization to alter their meanings (Jappe, 59). Here the idea was to break the dominance of art, words, and novels as private property by altering and recombining fragments, returning them to their place as "collective inheritance" (Wark, 37). This was the opposite of quotation, or capitalist appropriation of literary private property.[3] *Maverick* also employed *détournement* in what came to be known as the "Pappyisms," pithy phrases turned against themselves that always pointed to values that were the opposite of the established values of both the society and the Western, including the epigraph at the beginning of this chapter and the

following from the episode "Last Wire at Stop Gap": "Hard work never hurt anybody . . . who didn't do it" (Robertson, 40).

Foremost among the ways of disrupting the society of both production and consumption were the provocations that the letterists and their followers called *situations,* which Debord appropriated. The most famous of these was at Easter Sunday High Mass at Notre Dame in 1950 when the letterist Michel Mourre, dressed as a Dominican monk, climbed to the pulpit and began a poetically *détourned* sermon that, before it was drowned out by the organist and before he was led off to jail, included the phrase "Verily I say unto you: God is dead" (Wark, 19). The letterists disrupted theatrical performances, gallery openings, and film festivals (Jappe, 48). Debord then extended these disruptions into everyday life when, in his psychogeography of the open market at Les Halles, he noted with pleasure the way "vegetable vendors made temporary barricades at delivery time, forming a changeable maze" that halted the flow of traffic in the area (Wark, 83).

The perpetual schemes in the *Maverick* series that could disrupt the daily flow of activity, often staged for the purpose of counteracting the more systematized corruption of the wealthy or to combat the brute power of violence always at play in the West, might in this light be read as *situations.* In "Diamond in the Rough," Bart is swindled out of $17,000 in San Francisco and shanghaied to New Orleans by a ruthless aristocrat who sells deeds to a nonexistent diamond mine. Bart then spends the episode cultivating a down-on-their-luck countess and her daughter in a successful scheme to defraud the illicit businessman and get his money back. In "Duel at Sundown," Bret is challenged by a bullying Clint Eastwood, the fastest gun in the county. To ward him off, Bret has his brother impersonate the deadly gunslinger John Wesley Harding, whom Bret "guns down" in the street, causing the bully to flee and exposing him as a coward.

Separated at Birth, Bret Maverick and Jack Kerouac: The Beats and the Wandering Western Antihero

> "The two greatest evils are hard liquor and hard work."
> *"The Brasada Spur"*

Another movement contemporaneous to the series was that of the beats. It would seem ludicrous on the surface to compare a television Western protagonist, even an antihero, with Jack Kerouac's definition of a beat as one who espouses "mystical detachment and relaxation of social and sexual tensions" (Watson, 5) and poet Allen Ginsberg's description in *Howl* of the beat attitude as a "protest against the dehumanizing mechanization of American culture, and an affirmation of individual particular compassion in the midst of a great chant" (Charters, xviii). But at the time of the program's creation, the beat ethos was in the air—the show premiered the same month, September 1957, as *On the Road* was published to a rave review in the *New York Times* and spent five weeks on the best seller list—and *Maverick* was in some ways a reinterpretation of that ethos for a mainstream audience.

In the late 1940s and early 1950s, Kerouac had described a "transient generation of poets on the road" who "lived a rough and tumble lifestyle." The word itself began as a description of a generation that was beaten, as Kerouac characterized them, wandering "'beat' around the city in search of some other job or benefactor or 'loot' or 'gold'" (argot for drugs). The word then also acquired the definition from the bebop and jazz musicians of beat as hip and the search as a quest by a "Lost Generation" harkening back to that of the 1920s (Charters, 50–51). The weariness that the beats experienced has been attributed to, as chronicler John Clellon Holmes described, "the feeling of having been used," being born in a "dreary depression," "weaned

during the collective uprooting of a global war" and amid the "topsy turvy world of war bonds, swing shifts and troop movements" ("This Is the Beat Generation," 223–24).

This generation, he claimed, had come of age as "veterans of three distinct kinds of modern war, a hot war [World War II], a cold war [begun by 1948 only three short years after the other war ended], and a war [in Korea] that was stubbornly not called a war at all, but a police action" (229). The fledgling beat movement had not fared well during the Korean War, with its few members "vanishing into jails and madhouses or . . . shamed into silent conformity" (224). However, in the years after the end of the war in 1953, as Kerouac described it, postwar youths "had picked up the gestures and the style [and] soon it was everywhere" (Charters, xxx). *Maverick*'s antiestablishment attitude "gave voice to viewers' dissatisfaction with the predictable, buttoned-down TV of the '50s" (Garner and Winokur, 67), with the term "buttoned-down" itself functioning as mainstream code for what the beats would have referred to as staid conformity.

The way the beat attitude was translated onto television is apparent in the medium's reworking of, for example, William Burroughs's definition of "beat" as "to take someone's money . . . addict A says he will buy junk for addict B but keeps the money instead. Addict A has 'beat' addict B for the money" (Charters, xxiii). A modified version of this attitude can be seen in the continual scamming of the Mavericks, who were constantly losing then reclaiming the $1,000 bill with which they traveled. An example is when Beau (Roger Moore) saves Bart's life not because he was intent on rescuing him but because he was pursing the $1,000 Bart had "beat" him out of in "Hadley's Hunters." Ginsberg's description of Times Square, a beat mecca, as a "new social center," "lit in brilliant fashion by neon glare and filled with slot machines, opened day and night" (Watson, 76), might equally function as the modern equivalent of *Maverick*'s saloon or back parlor card game that the brothers would often pursue to all hours.

Likewise, Kerouac's lionizing of and companionship with Neal Cassidy, the subject of *On the Road,* though he was a "perfect natural sociopath" whose adolescence was dominated by "cars, theft and sex" (Watson, 80), is akin to the Maverick brothers' constant rogues' gallery of scammers without a conscience, such as Dandy Jim Buckley and Samantha Crawford, who often led them down a destructive path. Most presciently, the beats described themselves as "intent on joy" (Charters, xv), "unrestrained by guilt and fueled by hedonism" (Watson, 81), which directly corresponds to the pleasure impulse in Maverick's character that was so contrary to that of the standard Western hero. As Huggins described him, Maverick "lived life fully, joyfully, and without any of the doubts and anxieties of modern conformity" (Robertson, 45).

Two additional comparisons, one biographic, one generic, also suggest themselves. Garner, whom Huggins claimed "knew the character so well" (Strait, 129) and who argued "I'm playing me" (Yoggy, 237), had lived a protobeat lifestyle as vagabond and gambler, sometimes skirting the edge of the law, prior to securing the role, and it was this experience that he brought to the show. James Baumgarner, the youngest of three brothers and nicknamed "Little Bum" (Garner and Winokur, 3), grew up in the dust bowl of Oklahoma where, he explained, there were two kinds of settlers in the great land grab: boomers and sooners. The latter, those who "snuck in *sooner* than the law allowed," characterized Garner's grandfather. Garner left home in his early teens, fleeing his stepmother whose molesting of his brother he says "gave me sympathy for the underdog" (11). On the road he worked mainly in Texas and California in food markets and clothing stores, cutting trees for the telephone company, as a dockworker, and as an "oil field roughneck," all the while fighting being drafted by the U.S. Navy (10).

Each job Garner would "quit as soon as I'd saved enough money to coast for a while" except for a job as an insurance salesman, which he could simply not abide because it meant

scamming "a widowed mother of three who can't afford to put food on the table" by scaring her into buying insurance (Garner and Winokur, 16). Though a decorated combat veteran of the Korean War, he found more valuable his military time spent with a Reno blackjack dealer who taught him card tricks he would ultimately use on the show. Garner spent his army-mandated R&R time in Japan recuperating from a wound as a "dog robber," someone who operates just barely inside the official regulations, skimming off the top, which in his case meant installing comforts such as a bar "stocked with the best alcohol" and a swimming pool (Strait, 20–21).[4] Back from Korea, in his immediate pre-*Maverick* days he spent his time hanging around "the pool hall, racking balls and picking up a little change on the side hustling snooker and playing cards" (Garner and Winokur, 32), perfect training for the *Maverick* character.

In terms of genre, the show reached beyond its Western roots and functioned as a prototype for a new television genre. Maverick was a wandering Western hero, a Warner Bros. staple, but the wandering, rather than simply being a device for generating stories, also marked *Maverick* as a series that in both Huggins's oeuvre and on television in general paved the way for the adoption of a more alternative kind of road series. Huggins followed *Maverick* with *The Fugitive,* in which, as the opening of the show stated, the lead character "toiled at many jobs" in his wandering to escape the law as an innocent but convicted murderer. Later in another Huggins series, *Run for Your Life* (1965–68), Ben Gazzara adopted an itinerant though extremely elegant and hedonistic lifestyle rationalized for television by the fact that he was dying and had only two years to live.

During *Maverick*'s run, *Route 66* (1960–64) incorporated the beat mentality as a commercial adoption of Kerouac. The series also anticipated the hippie wanderings of the motorcyclist in *Then Came Bronson* (1969–70), whose meanderings at last could be aimless, and the later fleeing of an amnesiac hunted by U.S. spy agencies in the paranoid government series *Nowhere Man*

(1995–96). A recent wrinkle in the road series that harkens back to Huggins's need to rationalize the characters' wandering can be seen in two of J. J. Abrams's contemporary road series, the apocalyptic tribal groupings after the extinguishing of electricity in *Revolution* (2012–14) and the attempt to reinvigorate elements of the paranoid government series in the era of the national security state in *Believe* (2014–), both at least partially inspired by *Maverick*'s borrowing from Kerouac and the beats.

Crooking a Crooked House:
Not Situational but Situationist Ethics

The episode "Shady Deal at Sunny Acres," one of the most acclaimed of the series and often credited as the inspiration for the Paul Newman and Robert Redford film *The Sting,* is a summary of all three countercultural movements from which *Maverick* draws. Bret spends the episode rockin', thinkin', and whittlin', the latter a kind of Western flâneurial activity. Meanwhile Bart, through an extended but calculated *dérive* and a situation involving a *détournement,* or turning of the speculative enterprise on its head, aids his brother in recovering money stolen from him by an unscrupulous banker. In the episode, Bret goes from being beat by the banker and a laughing stock in the town to triumphing through his panache and that of his brother and with the aid of a host of the series' recurring hipster hucksters. Bret moves from the town's odd character to someone who teaches the town a new and ironically more honest way of living, as Kerouac claimed the beats had pioneered. It was episodes such as this one that occasioned Blair Bolles, who in *Einstein Defiant* characterized the physicist as a kind of outsider himself, to declare Maverick "the true prophet of the '60s and . . . [the] lost ideal of the '70s" (qtd. in Robertson, 102).

"Shady Deal at Sunny Acres" may be thought of as the quintessential episode of the series and is one of the few with a teleplay by Huggins, who often preferred to distribute the

credit to other writers. The episode begins with Bret exiting a saloon and depositing $15,000 after hours with sanctimonious bank co-owner John Bates. Eyed suspiciously by the banker, Bret explains in the best flâneurial fashion that the money was earned in a poker game by "fate and the friendly laws of probability." The next day Bates denies the deposit and uses his position as respectable financier to discredit the transient Maverick, who asserts that he will retrieve his money from Bates but then spends the rest of the episode whittling in a rocking chair outside the hotel across from the bank, claiming whenever anyone asks him if he is succeeding in getting his money that "I'm workin' on it."

There is a plot that Bret has hatched, but the constant rockin' and whittlin' and the repetition of "I'm workin' on it" is the most direct the series ever came in its validation of the virtues of laziness and its critique of the near psychopathy of productive labor. The phrase, and its constant repetition, is designed to recall Melville's own critique of the corrupting drive toward ever more intense accumulation in his legal functionary Bartleby's retort whenever he is asked to work: "I would prefer not to." "Bartleby, the Scrivener" is referred to directly in the episode when Bart renames himself Bartleby. The Calvinist contempt for the simple act of contemplation, an attitude favored by the flâneur, the situationist, and the beat, is highlighted in the episode as Bret becomes the laughing stock of the town, even as he continues to maintain the value of nonproductive labor, rephrasing "I'm working' on it" as the biblical "Cast thy bread upon the waters, for thou shall find it after many days" from "Ecclesiastes 11:1."

Garner clearly relished the role, wallowing in indolence, and in terms of the extratextual layer of his acting, he claimed that he took the role because "I needed to get off my feet" (Garner and Winokur, 63). Huggins, very pleased with the naturalness of the performance, offered either role to him, and "Jim picked the role I thought he would pick: the Maverick who

does nothing" (Robertson, 101). There is also in the enjoyment of contemplation and its validation as labor an allegory of production highlighting not the Maverick of action, Bart who performs the con, but the Maverick of reflection, Bret who maintains that he is not just rockin' and whittlin' but "thinkin' too. That's important." This is the work that the studio constantly devalued in refusing to hire full-time writers and in its view of writing as simply recycling the studio's stock supply of plots and characters.

The episode also shares the attitude of the situationists and beats that mainstream society, in this case the upright American towns of the Gilded Age of the 1860s (and the American imperium of the 1950s), though endowed with sobriquets such as "Sunny Acres," were, behind their moral uprightness, hotbeds

of corruption, and that corruption was as much systemic as individual. John Dehner's Banker Bates[5] drips with procedural righteousness as he tells Maverick in the dead of night that "No banker gives a man a receipt for money unless he has counted it, not if he expects to be a banker for long." Bates displays the same uprightness the next day when he denies ever having taken the deposit: "I know all our depositors, but your face isn't familiar to me." He then sends for the sheriff, convincing his lackey that Maverick, in demanding his money, "is up to something." Bates also threatens to resort to violence to get rid of Maverick, accosting him in his rocking chair and claiming that "I carry a gun and haven't had a real good fight since I became a banker," exhibiting the force that backs up the rule of the financier. Later as the scam unfolds, we see Bates's productive labor, his Calvinist spirit, working overtime to accumulate more money for himself. The show contrasts this pugnacious dynamism with Bret's intellectual labor of the bohemian, a nonviolent labor.

The episode delights in putting on display both the corruption of the banking and financial systems as a whole and the general mistrust this corruption engenders in ordinary

The "gentle grafter" being conned by a banker, played by the series' favorite villain John Dehner, in "Shady Deal at Sunny Acres."

people. Bates, again exuding false virtue, repeats several times the phrase that is the counter to Bret's "I'm workin' on it": "After all, if you can't trust your banker, who can you trust?" Bates, not sensing any profit in Maverick's initial approach to him after hours, tells Bret that the bank is closed. Bret's reply is that "They usually are, just when I needed it the most," implying a cognizance that banks profit on depositors' money and are run for the convenience of the bankers, not the depositors. The next day when Bates denies the deposit, Bret says, "I'll take the whole $15,000. I have a coffee can in my room where it might be safer," again implying that money in a bank is circulated at the customer's expense rather than kept.

The personality of Bates, the capitalist accumulator, is described by his ex-partner Granville after Bates has used Maverick's money to buy him out in what amounts to a hostile takeover: "My former partner paid seven dollars for the suit

he's wearing this season, lives in the cheapest boarding house in town, has no family, and I've never known him to have a generous impulse." Later, after Bret pays a farmer who owns worthless stock that is part of the scam, he tells the farmer that Bates would never have paid him the $1,000 he had claimed he would pay for the stock. The farmer nods his head and says in a way that seems to represent a common truth about bankers, "I believe you there."

The *détournement* of the scam emphasizes the way that Bates, because of his banker's greed, is pulled into a get-rich-quick scheme that exposes the fluid corruption of the Gilded Age. The unsavory Bates, dripping righteousness, tells "Bartleby," whom he believes to be a financial prospector for British interests, that "The West is full of clever confidence men. 'Thieves' is a better word." Bates is unaware that everyone he will meet and believe in is part of the stable of *Maverick* confidence men and women, all of whom represent in more heightened form the corruption that bankers such as Bates practice daily. They are all paid for their part in the scam, but the performance of the scam, the unfolding of the situation, depends on a collective of flâneurial thieves outwitting the systemic brigandage of the banker.

"Bartleby" begins the con by telling Bates he is buying up what is considered worthless stock on a Nevada silver mine that has become valuable because of britannium veins collapsing into the mine (the mineral itself being a joke, since he claims to be working for British financiers). Bart arouses Bates's greed by presenting the gambit as a bonanza: "In every man's life, there is one opportunity. Mine's coming in the prime of my life." Bart further excites the corrupt banker in Bates by telling him, in a literary *détournement* that plays with the series' Pappyisms, that while buying up the stock for pennies may be unprincipled, "As my old pa—ah, father—used to say, 'There are times a man must rise above principle.'"

When Bates watches Dandy Jim Buckley posing as a stock broker from a major firm (pointed out by Gentleman Jack

Darby posing as a trader) pay $15,000 for stock "bought" from Samantha Crawford, his eyes beam. Bates is then only too willing to advance "Bartleby" what amounts to $15,000 to buy more of the actually worthless stock from Big Mike McComb, posing as a businessman named Callahan, by being thrown out of Callahan's office and thus seeming to be leaving his place of work. Each of the cons by the bohemian hucksters works for a moment as they impersonate their more "reputable" counterparts, exposing in the impersonations the duality of outright and upright thieves.[6] This duplicity is handled most cheerfully by Samantha, posing as a naive victim of stock fraud ("I was never much of a businesswoman"), who at first refuses to sell her stock ("Its dishonest. . . . It almost seems as though I'm cheating you") and is later revealed to have swindled Bart, returning less of his money than they agreed. On being found out she replies, "I guess I made a teensy mistake." This is the flâneuse, a full and equal member of the bohemian collective.

The immediate result of the situation is that Bates realizes he has been scammed as the camera moves in on him and he says about Bret, "He *did* it." There is a longer-term effect of the *détournement,* though, and that is a change in the town, with the grifters remaking it, ironically, as a more honest place. Bates is found guilty of embezzlement of the money he gave to "Bartleby," and the honest Granville resumes the presidency of the bank. The sheriff, who, working in concert with the banker, had attempted on Bates's nudging to throw Bret out of town, receives the piece that Bret had been whittling. The piece turns out to be a donkey or, more accurately in the sheriff's case, an ass. As Bret boards the stage he says to the sheriff, "It isn't often I can say this, but I feel like I'm leaving Sunny Acres a better place than I found it." As the stage departs, the camera pans across the ramp in front of the hotel and finds Bret's chair, the symbol of his critique of the town's "productive" corruption and of his own bohemian (flâneurial, situationist, beat) contemplation, oh so gently rocking back and forth.

79

The "Gentle Grafter" and Geopolitics

Maverick's Antiauthoritarian Challenge to the Ethos of the Cold War

Maverick's inauspicious debut on network television in September 1957 occurred at a moment when Cold War tensions were easing, with the legacy of the two Joes, Stalin and McCarthy, beginning to be refuted and with the space race and the Russians' launching of Sputnik momentarily displacing the nuclear arms race. The opening occasioned a mild questioning of the Cold War precepts in the cultural realm as a whole and in the screen Western, with the ability of Ethan Edwards (John Wayne) to maintain order in 1956's *The Searchers* seen as intimately bound up with a cruel and racist "pathology" (Corkin, 163). The television Western, though, came of age at a moment when, because of financial entrenchment and the still potent effects of the House Un-American Activities Committee (HUAC) and McCarthyite censorship, "Hollywood was at its least bold" (Corkin, 12). The genre was a repository of the most backward and right-wing Cold War rhetoric validating and justifying the projection of American militarism across the globe through

the promotion of a legal representative (Marshal Dillon, Wyatt Earp) whose right to deploy violence was awarded "not as a result of diligence but as part of his natural constitution" (Corkin, 102).

On the other hand, the opening sequence of "Point Blank," the second episode of *Maverick*—that is, the initial moment the protagonist was meant to be onscreen—shows the series' lead character being run out of town, pursued by a sheriff's posse, and first visible in other than archive footage when he pops up from behind a boulder, grinning at eluding the law. Maverick's itinerant, nonviolent nature, his defense of both himself and other outsiders, and his refusal to own and profit from property located him at the opposite end of the spectrum from the entrepreneurial, moralistic, often McCarthyite, lawman who was most interested in hounding him out of town.

The series attempted to critique and alter the discourse on the law, and by implication American righteousness in the Cold War. *Maverick,* in its passive pursuit of pleasure, was part of a decades-long debate between its creator Roy Huggins and the right-wing ideologue Jack Webb, with the series even going so far in an episode as to parody Webb's *Dragnet:* "This is the West. I work here. My name's Maverick." The show specifically critiqued the representatives of the law as variously incompetent, moralistic, hypocritical, and, most often, self-serving and corrupt, a critique that by extension applied as well to the legal guardians of the U.S. empire during the Cold War.

Riding the Cold War Range from Minneapolis to Minsk

Television and the Cold War had impacted the American consciousness at precisely the same moment. In 1948, the year of the Berlin Blockade and Airlift and the election of President Harry S. Truman, whose doctrine the previous year had announced U.S. worldwide readiness to combat communism, and

the subsequent defeat and erasure from public discourse of the leftist platform for peace of Henry Wallace, television sales increased almost 700 percent from the previous two years. This was a moment when Ed Sullivan and Milton Berle made it fashionable for celebrities to show up on what the studios referred to derogatorily as "the small screen" (MacDonald, "Television and the Red Menace"). In the same way that American business and elite government interests recognized that a permanent war would restart an American economy that had become sluggish after the peak moment of World War II when the United States was at nearly full employment, these same elites also reduplicated their war propaganda effort to sell this latest war, one that seemingly had no end. The government recognized radio, television's forerunner, as an effective means of promoting its viewpoint during the Great Depression of the 1930s and, more stridently, after the Japanese attack on Pearl Harbor in December 1941 but preferred a policy of "maintaining the structure of broadcasting as a privately owned commercial business but inundating the air with propagandistic information and entertainment" (MacDonald, "Television and the Red Menace").[1] In the early years of television at the time of McCarthy and HUAC, the pressure to promote a new permanent war increased, particularly in the television Western, a genre that along with its screen cousin "molded national identity most profoundly" in the twentieth century (Burgoyne, 8).

Indeed, the honest, selfless Western hero was defending not just the frontier but, by extension, "the Free World against the barbarous onslaught of Communism" (MacDonald, "Television and the Red Menace"). The Western town was also the outpost of the empire in the U.S. Pax Americana, and the Western lawman's "code of conduct" was "the expression of a rational and moral imperative that will ensure progress and promote the development of civilization" (Corkin, 29). *The Lone Ranger* at the height of the Cold War was explicit in its statement of standards about the masked man's patriotism, which meant

"respect for law and order, and the selection of officials who merit such respect" (MacDonald, "Television and the Red Menace"). One newspaper editor at the time suggested that contemporary Americans, "though a peaceful people at heart," "wouldn't be pushed" by the supposed Russian bully (whose economy was devastated by the war and whose weapons were far inferior) and would retaliate with "six-guns, fists, or lariat" (MacDonald, "Television and the Red Menace"). The television Western, as Raymond Durgnat put it in describing the Western as a whole, through a "sleight-of hand . . . palms off Manifest Destiny as freedom" (80).

The adult Western appeared on television after the Korean War at a moment in the Cold War that represented the "limits of actual military engagement" (Corkin, 165), since the war had ended in a stalemate and had along the way threatened a nuclear conflict and an all-out conflagration with China.[2] A key word in the bellicose discourse became "containment," with the centrist view of the war now being a "desire for a geopolitical stasis" (165). If the Western was, as *The Rifleman*'s Chuck Connors described it, "the American fairy tale" (Macdonald, *Who Shot the Sheriff?,* 74), the television adult Western most often told a right-wing tale not of moderation but of rationalization for the excessive force deployed in the Cold War. The successes in the Western were equally a compensation for the clear victory that now seemed less plausible on the political plain but that the right wing still pushed for under the rubric of "rollback."

Gunsmoke's James Arness explained that viewers tuned in to the show to "escape from non-conformity," with conformity in the right-wing parlance being understood as "knuckling under" to the values of peace and global equality and denying any recognition of the world's most powerful military power repeatedly drawing its gun and threatening the rest of the world (Macdonald, *Who Shot the Sheriff?,* 75). The right-wing press understood and echoed the message of the adult Western, with William Richerbacker of the *National Review* comparing a sheriff

telling "an interloper to leave town" to a wish that the United States would do the same to Nikita Khrushchev (Macdonald, *Who Shot the Sheriff?*, 75). David Steele Temple in the *American Mercury* cited the adult Western directly in campaigning for a potential third world war and for the use of nuclear weapons. He asked, "Would a Wyatt Earp stop at the 38th Parallel, Korea, when the rustlers were escaping with his herd? Ridiculous! Would a Marshal Dillon refuse to allow his deputies to use shotguns for their own defense because of the terrible nature of the weapon itself? Ha!" (MacDonald, *Who Shot the Sheriff?*, 75).

Maverick's premiere on network television in September 1957, two years after *Gunsmoke* and *Wyatt Earp* premiered, coincided with a moment when there was a slight easing of tensions in the Cold War mainly from the Soviet side, as the launching of Sputnik that began the space race seemed for a moment a technological displacement of the nuclear arms race. At the same time, Khrushchev came to power criticizing Stalin's excesses. Earlier that year McCarthy, who had initiated the Red Purges, died of complications exacerbated by his alcoholism. As part of these "cracks that begin to disrupt the Cold War consensus," on the screen John Ford's *The Searchers*, with its brutal, cruel hero patrolling the West in an empty quest for revenge, seemed to "locate the limits of frontier mythology" and signal the quintessential Western director Ford's entry into a period of "acute ambivalence," "pessimism," and "uncertainty" about that myth (Corkin, 128).

Against the television right-wing Western's urging of continued "hypervigilance" (Hoberman), Maverick's pacifism, his reluctance to draw a gun, and his constant attempts to peacefully resolve conflicts that interfered with his gambling appealed not to traditional Western viewers but, as Huggins claimed, "to a new audience of young people, of college people" (O'Shea). This was a generation, as beat chronicler John Holmes put it, that was sick of having lived "in the shadow of the bomb," of knowing that "peace was only as secure as the next headline";

the generation that grew up in this "cold peace," Holmes wrote, "may make no bombs" but "will probably be asked to drop some and have some dropped on it" ("The Philosophy of the Beat Generation," 228).

This wariness about war reflected Garner's attitude. He had fought in Korea and had been decorated but said that "I was not a hero" and that "We'll end wars only when we stop glorifying wars and those who take part in them" (Garner and Winokur, 30). In a final quirk, in the discursive moment in the creation of the series, the show's sponsor, Kaiser Aluminum, was also attempting to convert from war to peacetime. Henry Kaiser, owner of the third-largest aluminum company in the world (Robertson, 17), had made his money during the war in manufacturing prefabricated cargo vessels, called Liberty Ships, which, similar to *Maverick's* production schedule, took six days to assemble. After the war, the company was attempting to enter the consumer market by converting its wartime metal practice to a home product, aluminum foil. *Maverick* became the advertising vehicle for that conversion. Apropos of the wartime contracts whereby much money was made by business with little regulation, Huggins described Kaiser as "a bit of a con man himself. I think he saw himself in Maverick and he said 'I want that show'" (Strait, 74).

The implied difference in attitude toward the Cold War is apparent in a comparison of the trajectories of *The Legend of Wyatt Earp* and *Maverick*. The former, branded "the first historically based adult Western" (Yoggy, 133), followed an increasingly more violent path as Wyatt Earp cleaned up Wichita in season one and then moved on to Dodge City in season two, which began with a walk down Front Street in which he shot, almost at random, legions of marauding hordes and ended by throwing a bushwhacker down the saloon stairs and beating him. After this demonstration of frontier justice, Earp was described by one of the townspeople hiring him as "the most violent peace officer I know." The character's sadistic delight

in gunplay and confrontation continues unabated as Earp then moves on to Tombstone, where the final two seasons and the last five episodes are a buildup to the ultimate bloody shootout at the O.K. Corral.

The television Earp certainly epitomized the American Cold War belief that "extraordinary might necessarily accompanies extraordinary right" (Corkin, 102). Earp's violent conduct—the series was described as one where "the action is fast and furious" (Yoggy, 139)—was in the service of being able to declare the Western town "civilized," meaning that it was a stable place for eastern money interests to invest. Indeed, the actual Earp owned part of the gambling concessions in Tombstone, and thus both the actual and television Earp fulfilled the function of protecting those investments in a way that Stanley Corkin claims was "similar to the job of the postwar U.S. military" in its interventions to protect U.S. corporate interests throughout the Cold War (41).

The trajectory of *Maverick* veered in an opposite direction as the series got less confrontational and moved away from

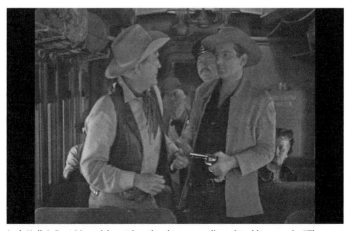

Jack Kelly's Bret Maverick getting the drop on a dim-witted lawman in "The Third Rider."

violence or, if systemic violence was a subject, presented it in ever more critical terms. In the episode Huggins wrote as the series pilot "Point Blank," Maverick engages in several fistfights and does end up shooting the villain in the end, but by season two's "Shady Deal at Sunny Acres" the drive to settle disputes by one's wits is tantamount, and the peaceful scam takes precedence over any gunplay. In summarizing his lead character's constant tendency to avoid disputes, Huggins stated that "'Cowardly' would be too strong a word to [describe] Maverick. 'Cautious' is possibly more accurate and certainly more kind" (O'Shea). As for critiquing a militarist and nationalist attitude, in season one Bret, ever the pacifist, explains that when the two brothers went off to the Civil War his pappy said to him, "If either of you comes back with a medal, I'll beat you to death." Bret adds that they never shamed their father.

Perhaps the most anti–Cold War episode was the two-parter to end season four, "The Devil's Necklace." The episode opens in the aftermath of an apocalyptic conflagration and shows a fort littered with the bodies of soldiers and Indians, with only an unconscious Bart Maverick left alive. His flashback details how the hawks on both sides, an ambitious army officer disgruntled over not getting a promotion and an Indian leader who believes he is invulnerable, pushed war, spurred on by the naked financial interests of an unscrupulous trader (John Dehner again, the banker from "Shady Deal at Sunny Acres"). There is a bitterly elegiac mood to Bart's reminiscing that suggests that this destruction could have been avoided by reining in aggression on both sides and by sanctioning the greed of the (American corporate) merchant class.[3]

Roy Huggins's Noirish Aphorisms versus Jack Webb's Terse Interrogations

Roy Huggins brought to television his early aesthetic and political experience; his absorption of the tenets of the film noir

critique of capitalism, partly prompted by his political acumen and membership in the Communist Party; and his blacklisting, subsequent capitulation to the HUAC leftist purge, and partial refutation of that moment. Though admittedly in diluted form, he continually challenged right-wing ideologue Jack Webb's glorification of the Cold War culture of informing and surveillance in what amounted to a four-decade debate between these dueling auteurs.

Huggins came to Hollywood in the late 1940s in the moment of the ascendance of the police procedural when the once-triumphant outside-the-law film noir hero or heroine was about to be replaced in the crime genre by the working- or middle-class cop (e.g., *Armored Car Robbery,* 1950, and *Detective Story,* 1951). Huggins's literary model was Raymond Chandler who, Huggins pointed out, critiqued the rule of law that governed the homeland capitalist consensus during World War II by never mentioning the war and by writing novels in which the reader was "never sure who the good guys were and who the bad guys were" (O'Shea).

His two key screenplays continued this trend and were bitter accounts of an American system that through its incessant promotion of consumerist objects was making people more and more desperate to achieve a lifestyle that was beyond their means, the epitome of what Thom Andersen has dubbed "*film gris.*" *Too Late for Tears* (1949), from Huggins's *Saturday Evening Post* serial, features Lizbeth Scott as the wife who sees nothing but a mortgage and paying off creditors in her future.[4] When a windfall arrives in the form of a bundle of money erroneously thrown in her and her husband's car, in order to retain the money she kills both her husband and the blackmailer who was supposed to receive it. *Pushover* (1954) is an even more disenchanted view of society and particularly the law in the form of a *Double Indemnity*–like narrative in which that film's lead, Fred MacMurray, reappears as a cop who is so overcome with greed and lust (for ingenue Kim Novak in her first screen

appearance) that he murders his soon to be retired partner but, as with *Double Indemnity*'s Walter Neff, does not get "the money or the girl."[5]

Huggins's sympathy for the character who straddled the law, grounded in Chandler's noir hero, was also perhaps a product of both his political involvement and an atonement for his having crossed over to the side of the law in an unconscionable fashion. Huggins joined the Communist Party, as had many of the Hollywood Left, during the war when, he claimed, the Popular Front line of the party "was hard to distinguish from the Democratic Party" and stood firmly against fascism in a moment when he feared that "the center had collapsed and we had a choice between communism and fascism" (O'Shea). He left the party near the end of the war and was blacklisted following the 1947 Waldorf Statement whereby the studios vowed not to hire communists or former communists. With the Randolph Scott Western *Hangman's Knot* (1952) that Huggins wrote and directed, he briefly exposed the mercenary nature of the blacklist by signing a contract for a lower fee and then being allowed to direct the film by Harry Cohn at Columbia, one of the signatories of the Waldorf Statement.

Huggins remained on the blacklist, though, and in 1952 testified as a "friendly witness" before HUAC, confirming nineteen names as former Communist Party members. He rationalized his testimony by claiming that the names were already part of the public record, though Victor Navasky later revealed that three had not been identified, including a fellow writer (282). Huggins did go out of his way subsequently to hire blacklisted writers and later said that "to cooperate with it [HUAC] . . . was the wrong thing to do" (Marc and Thompson, 145). But the damage was done, and by participating Huggins ratified a process that he himself argued, quoting Justice Hugo Black, was not about national security but instead was undertaken "to punish former Communists for having been Communists" (O'Shea). It would have been much better if he had followed

the advice of *Maverick*'s Pappy, as had many blacklisted exiles: "If you can't fight 'em and they won't let you join 'em, you best get out of the country."

On television, despite his political lapse or possibly to atone for it, Huggins almost single-handedly instituted a change in the Western and crime genres that promoted the antiauthoritarian protagonist whose primary value was not upholding the law but rather pursuing pleasure. Thus, *77 Sunset Strip*'s Stu Bailey "went out with women instead of demanding 'just the facts' from them" (Marc and Thompson, 142). These traits stood against the determinedly grim seriousness of the Jack Webb "hero" whose righteous crusade against villainy promoted domestic surveillance and validated the McCarthyite paranoia instilled in the populace by the forces of law and order. Webb initiated this four-decade dialogue by importing the techniques of the 1950s cinematic police procedural to television in fashioning the television docudrama *Dragnet,* which claimed that "the story you are about to see is true," using access to Los Angeles Police Department files as a sign of its veracity. In 1954 with HUAC and McCarthyite persecution still in full swing, this one-sided "truth" presenting "just the facts" from the point of view of what was seen as one of the most reactionary police forces in the country was watched by 56 percent of television households.[6]

Huggins countered the imposition of the conservative police procedure by his own importation to television of the 1940s noir outsider, most presciently in the two series he created that altered both their genres, *Maverick* and *77 Sunset Strip.* He claimed, apropos of Maverick, that the noir protagonist was, in actors such as Humphrey Bogart's dark incantations, always a "reluctant" hero (Robertson, 6). Maverick, as we have noted, was a gambler with "more than a little larceny" in his heart (Anderson, 224), a "disorganization man" whom Huggins claimed opposed himself to the middle-class conformity outlined in William Whyte's 1956 study of the corporate middle class *The*

Organization Man (Marc and Thompson, 145). Likewise, the detectives in *77 Sunset Strip* were as far away from Joe Friday grimness as was possible while still loosely maintaining the conventions of the genre.

This series' characters consisted of a pleasure-seeking amalgam of hipsters (the parking lot attendant Kookie Burns), global gadabouts (the lead private investigator Stu Bailey, whose PhD from Columbia University in Indo-European languages came in handy in his sorties to, for example, the fringes of the art world in Paris in the episode "A Check Will Do Nicely"), and streetwise cons (the gambler Roscoe, always in need of a stake on the horses). In the series bible, Huggins had expressly delineated their differences from what he called the "clichéd private eye" whose police counterpart was Joe Friday (Anderson, 244). "Our protagonists will not wander about, asking interminable questions, and being slugged from behind" (244). The theme song alluded to the fact that the show, concentrating on Los Angeles as a pleasure capital, hovered on the fringes of the crime genre, extolling the virtues of the Sunset Strip as a place where "You find most every gal and guy, *including* a private eye."

An episode in season three of *Maverick,* "A Cure for Johnny Rain," parodied *Dragnet* and highlighted the differences in Webb's and Huggins's series. The episode, which opens with Webb-type narration, completely confounds the objective facts approach to detecting, as the highwayman whom everyone detests proves to also be the most likable cowhand in the town. Johnny Rain is a blackout drunk who changes personalities, and when Bret makes the townspeople aware of the truth, rather than locking Rain up, they make him sheriff. The character's psychological complexity and its acceptance by Maverick and ultimately the townspeople are a far cry from Friday's primitive assumptions about "criminality" posing as 1950s assumptions of a positivist "objective" truth.

Webb then countered *77 Sunset Strip* with *Pete Kelly's Blues* (1959), which featured his own type of hipster, a 1920s cornet

player who learns that he must protect his nightclub with McCarthyite vigor if it is to survive against the thinly veiled communist terror of the underworld. The series quickly died, but Webb was subsequently appointed head of television production at Warner Bros. and was able to wreak his revenge on the Sunset Strip. He dismissed all the characters except Efrem Zimbalest Jr.'s Stu Bailey, moved Bailey off the strip into the corporate Bradford Building in downtown Los Angeles, remade the formerly fun-loving Bailey as a buttoned-down organization man, and had him chasing communists across Europe, reinstituting the *Dragnet* Cold War determinedness. This "new" version of *77 Sunset Strip* was cancelled before the season ended.[7]

This dueling discourse continued[8] with Huggins's creation of the most anti-Webb series ever on the air, *The Fugitive,* in which every week the audience was called upon to "harbor" a convicted felon, Richard Kimble, whom those he came into contact with accepted as innocent. These same audiences, by implication, were enlisted in loathing the obsessed Joe Friday–type lawman, Lieutenant Girard, named for the law-and-order villain Javert of *Les Miserables,* who pursued Kimble beyond all reason to the ends of the earth. Huggins continued his wandering bohemian hero frequently afoul or on the edge of the law in such series as *Run for Your Life* (1965–68), *The Outsider* (1968–69), and *Alias Smith and Jones* (1971–73).

Webb, who had enlisted *The Fugitive's* David Janssen as a lawman in *O'Hara, U.S. Treasury* (1971–72), the only Janssen series to be cancelled after one season, finally scored a hit in his *Dragnet* return (1967–70) and the spin-off *Adam-12* (1968–75). In that series, Webb's concession to the social movements of the 1960s was to replace Joe Friday with a young blond hero whose "street cred" came not from his involvement in a social movement but from being a cop on patrol, and not even on the street but in a squad car. The duel ended with Huggins reuniting with Garner in the creation of *The Rockford Files,* directly countering the Webb-style rational representative of law and order with

an ex-con detective. Rockford lived in a trailer park, associated mainly with ex-cons like himself, and kept his gun in a cookie jar because "If I carry a gun, I may have to shoot somebody." The opposite of a dogged lawman, Rockford claimed that his strongest desires were to "pay his bills, go fishing with his dad and drink a few beers while watching football on TV" (Garner and Winokur, 129).

This was the crime series viewed not from the front seat of the squad car patrolling and surveying the populace but from the remote perspective of the outsider hounded into obscurity by the dictates of a system that made daily survival an ordeal. Far from validating the Cold War, Rockford's ostracized outsider, who barely eked out a living, called the miracle of American capitalism into question and for a while put an end to the self-righteous lawman. As Garner said of his combined work on *The Rockford Files* and *Maverick,* "I guess I have a knack for killing genres" (Garner and Winokur, 144).[9]

"You'd Best Be Moseying Along, Mister": Maverick and the Law

> Sheriff: "I want you out of town in ten minutes."
> Maverick: "Sheriff, I've gotten out of towns this size in five minutes."
> *"Point Blank"*

Maverick's characterization of the law and the Maverick brothers' relationship to it placed the show and them not on the side of upholders of the law as civilizing agency in the West and, by projection, as contemporary rationale for the Cold War against the "illegal" opponents of capitalism but rather often as fugitives from a tyrannical force that opposed their itinerant and pleasurable lifestyle. The show characterized and poked fun at this force as being incompetent, hypocritically self-righteous, and/or

outright corrupt. Frequently the sheriff, the law, in one of these three forms, also was a stand-in for the town as a whole and thus for a critical surveying of not only the landscape of the Gilded Age West but by implication the rule of the American Transnational Corporation (TNC as it was called at the time) in the global empire, the Pax Americana, of the 1950s.[10] Thus, the show featured the archetypes of the incompetent, the corrupt, and the demagogic (McCarthyite) lawman in its various episodes.

The incompetent lawman is epitomized in "The Third Rider," where Bart Maverick is mistaken by a foolish sheriff named Edwards for a third bank robber. The actual robbers corral Bart on the trail after one of the gang is killed and force him to assist in their getaway. Bart is captured by a lackadaisical lawman, who is "not much on tracking" and thus is unable to detect the moment of one thief dying, and by his equally unreliable deputies, who let the main robber Red get away and instead grab Bart. On a train back to Elm City to stand trial, Bart, handcuffed to Edwards, catches the eye of a young boy and mocks the sheriff, saying he hoped Edwards learned his lesson that "Crime doesn't pay." Bart then claims that he is the sheriff and Edwards is the robber, to which the boy then attests. When Edwards says he has a warrant, Bart calls Edwards "Light Fingers" and alleges that Edwards picked his pocket. Edwards ends up hogtied to a pipe in a baggage car. Later when Red's female accomplice, Dolly, gets the drop on Bart, Edwards this time takes him back to the jail in Elm City, where the deputy claims that Bart cannot be innocent because "Edwards doesn't bring a man back unless he's guilty."

While the McCarthyite townspeople, thirsting for revenge, consider hanging Bart, a crooked couple from the local saloon, Turk and Blanche, spring him from jail, in the process killing the deputy. Just before this second couple catches up to Red in time to kill him, Bart, who had been previously kidnapped by Red, exclaims to Dolly, "I just went through this with another happy couple like you, and you're prettier than she is," drawing

attention to the rampant and in this case duplicate greed and corruption in this landscape. "Light Fingers" arrives in time to accept as credible the bartender Turk's claim that he was trying to capture Bart, telling Turk "I ought to make you deputy" as the exasperated Bart, again professing his innocence, says in his best Mark Twain characterization of this corrupt era, "Every time I tell the truth I seem to wind up in trouble." Bart finally tricks Turk into revealing his murderous nature to Edwards, who nevertheless had admitted earlier that though Bart's argument for his innocence was reasonable, he would not let him go because "a lot of folks are still trying to figure out how I happened to be handcuffed in a baggage car"; that is, his humiliation was a stronger factor in considering Bart's fate than his sense of justice.

By far the most consistent image of the lawman was the corrupt sheriff who simply used public office for his own gain, again suggesting by analogy that the rule of law the United States was imposing on the world was not about the moral imperative of democracy but instead was about the economic drive toward the accumulation of wealth. In "Hadley's Hunters" Bart discovers that the sheriff the town is named after, who built his reputation on apprehending dangerous criminals, has in fact been arresting innocent bystanders for robberies committed by his deputies.[11] In "Holiday at Hollow Rock," a takeoff of the film *Bad Day at Black Rock* (1955), Bret is robbed by a crooked sheriff and must win the stolen money back from the sheriff by betting on a horse race. In "The Deadly Image" a former deputy marshal, Red Claxton, turns to murder and robbery—or, the series might be arguing, more overtly pursues what he has covertly been accomplishing behind his badge—and Bart, his lookalike, is pursued for the crimes. By far, though, the most thoroughgoing satire of a greedy lawman, a true legal representative of a town shown to be avaricious in the extreme, is Sheriff Chick Tucker—played by Ray Teal, who would later star as the upright Virginia City lawman in *Bonanza*—in the season two opener "The Day They Hanged Bret Maverick."

Bonanza's upright sheriff (Ray Teal) as a corrupt law officer finally behind bars in *Maverick*.

In the town of Hallelujah, Bret is framed for a robbery of $40,000 by the actual thief and then is quickly tried, convicted, and sentenced to be hanged. The mayor and town council urge him to tell where he hid the money instead of being so "incorrigible," and the sheriff explains that Bret's "orneriness" at continuing to profess his innocence "gives the town a wrong feeling" about this, the town's first legal hanging ("Oh, we had our share of lynchings"). To attempt to free himself, Bret then describes the money that he has supposedly hidden "in small bills of five, ten, twenty, so easy to spend," as the sheriff's mouth waters and his eyes bulge. The sheriff then, with the help of a black-suited coroner named Ollie and in a way that suggests the two are a blundering comedic twosome reminiscent of Stan Laurel and Oliver Hardy, arranges Bret's fake death and burial. Bret then easily outwits the sheriff and escapes, isolating him by playing on his greed in suggesting that he cheat the coroner

out of his share of the supposed loot. A thinly disguised Bret Maverick later reappears in the town wearing a moustache and claiming to be there to clear his brother Bret, telling the town that they hung an innocent man.

The townspeople, who had made book on whether Bret would tell them where the money was before the hanging, are nonchalant afterward about his possible innocence, claiming to be using the $1,000 bill they found pinned to his lapel to "build a better jail" in honor of him. Bret catches up to the actual thief by pursuing his "widow" Molly, the con woman moll of the actual robber whom the robber sent to Hallelujah to falsely identify him as the man who was hung. When Bret returns the money to the town minus the reward, the mayor explains that Molly must be put in prison and tried on the rationale that "I don't know what she's guilty of, but she is guilty of something and she's got to stand trial." The town now knows of the sheriff's deception and has imprisoned him and the coroner, but Bret points out that if they had not arranged his phony death, the town would be guilty of hanging an innocent man. "There is a little good in the worst of us" is Bret's parting message as the camera pans over to the corrupt "Stan and Ollie" behind bars. A little good perhaps, but not much, is the show's parting message about the religiously upright Hallelujah. In the show's view, its citizens, leadership, and the corrupt legal authority accurately represent the corruption of the town as a whole and, by analogy, of the contemporary corporate Cold War landscape as well.

The prime example of the McCarthyite lawman, the self-righteous and in some cases imbecilic protector of the law whereby a phony moralism eliminated reflection, was the Marshal Dillon–prototype Mort Dooley in "Gun Shy." This type persisted in the series and was the opposite of the quick-witted Bret Maverick, who melded with Garner's own predilections: "There's nothing worse than the steely-eyed sheriff. Brave bores me. Smart intrigues me" (qtd. in Strait, frontispiece). "The Saga of Waco Williams" was another ingenious way of satirizing this

character. Waco was not a sheriff, but over the course of the episode we watch him on his way to becoming one by pursuing ever more thoughtless, ruthless, and violent ends, to the chagrin of Bret and the acclaim of the (fascist? militarist?) townspeople of what is rightly named Bent City.

Bret rides into a town that is already the site of a range war between the ranchers and the farmers, who the sheriff, in the employ of the head rancher Colonel Bent, refers to as "rustlers." He accompanies Waco Williams, *Colt .45*'s Wayde Preston, whom he relates has recently killed six Indians when they were both ambushed. Bret tries exasperatedly to keep the violent Waco alive so he can collect the reward on an outlaw Waco is meeting in the town, imploring one gunman not to "kill my Golden Goose." Waco draws on Colonel Bent's son Karl, gets thrown in jail, is shot at again by the same son, and finally, facing a crew that far outnumbers him, shoots the colonel and kills his son. (His name is pronounced "Way-co," but that is to disguise the actual characterization, which is that he is wacko.) Maverick gives him some "friendly advice. Get out of town while you're still alive," to which Waco responds, looking in the direction of Colonel Bent's daughter, "She's kind of pretty, ain't she," suggesting a pursuit that will only further inflame a violent situation.

Waco relates a story from his childhood, about being made to eat dirt and forever after refusing to be bullied, as a rationale for why he reacts with aggression whenever he claims that he is being abused, in one case threatening that if Karl Bent comes back to the town "I'll kick him so hard he'll spend the rest of his life standing up." Waco represents the bully that globally the United States had become, having the largest military in the world and using it to impose its will, all the while claiming that it was always being pushed around. Indeed, Bart tells Waco in regard to this policy, "Your philosophy of life is wrong."

However, Waco's way of being is reaffirmed as instead the correct path by the town; by Colonel Bent, whom Waco has

shot; and by the colonel's daughter. Bent, the town patriarch, cattle baron, and local power who, it is related, claimed the land by force from the Indians, recounts his own (imperial, capitalist) philosophy of life to his daughter Kathy[12] to toughen her up: "You're born into a battle, you fight to breathe at the beginning, and you never stop fighting until the end. You reward your friends, you destroy your enemies, you stop fighting when you're dead." Bent, far from even being angry at Waco for shooting him, instead recognizes a kindred spirit and pushes his daughter on Waco, who now, with Waco having killed his progeny, will become the even more effectively violent son he never had.

This backwardly aggressive town, everywhere USA, a truly bent city, applauds Waco's gunplay in the streets and by acclamation rewards his violent behavior by making him sheriff. In one of the most famous endings in the series, Maverick on his way out of town stops, turns his horse back toward the town, and recounts Waco's triumph, which he had opposed all along. Maverick explains that Waco will be named sheriff, will marry the cattle baron's daughter, and in the process will acquire the largest ranch in the area, while meanwhile no one cares that Maverick rides out of town alone. He then looks directly at the camera, the audience, and asks, "Could I be wrong?" And indeed, given the overwhelming aggressive thrust of the Cold War consensus in the country and in the Western and the success accrued to those utilizing violent ends, his voice—and the show's—must have seemed a lonely one, questioning its own sanity as the character must constantly move from town to town. This was a country and an era in which *Maverick*'s pacifist logic went unheeded and violent wackos such as Waco, in all his McCarthyite vigor, were celebrated.

Conclusion

"Could I Be Wrong?"
Maverick's Antiauthoritarian Legacy
and the Fate of Resistant TV

This work has defined *Maverick*'s challenge to the constraints of network television in such areas as: its pushing of the boundaries of the Warner Bros. factory system of generic production; its contesting of the precepts of its own genre, the Western; its absorbing a variety of countercultural trends and translating them in a way that was acceptable to middle America; and, finally, its countering of the prevailing political attitudes of its era. In the guise of a comic Western, the series presented an alternate view of the West not as location of hardy plainsmen (and women), whose single-minded determination forged a great land, but rather as amplifier of the greed and corruption of the East in the Gilded Age in a landscape peopled with con men and women. This view of American society as, at base, corrupt extends even beyond traditional liberal television series in the line of *All in the Family* (1971–79) and *Mash* (1972–83) to what amounted to a radical rewriting of the American West and of American history.

This critique was always undertaken with a smile, employing the comic weapons of ridicule, parody, and irony to make its point and to remain palatable to its audience. The series extends far beyond most Westerns, including a series that also had an outsider dandy hero, its contemporary *Have Gun—Will Travel* (1957–63). That series, which did present an alternative Western lifestyle, nevertheless retained the efficacy of the lead character with a gun and the validation of the gunfight as the ultimate means of resolving conflict while featuring a mercenary protagonist more in line with the future U.S. use of companies such as Blackwater than with Maverick's pacifist inclinations.

Rather than locating the legacy of *Maverick* in the traditional line of liberal television, it might be more interesting to instead place it in a line of outlier series suggesting that shows that are different and offer a basic questioning of American military and economic values do not persist for long in the commercial medium of network television.

Maverick's most direct legacy exists in Roy Huggins's subsequent series, including *The Fugitive, Run for Your Life, Alias Smith and Jones, The Outsider,* and *The Rockford Files.* The indirect legacy of *Maverick* is perhaps in the persistence of the road series with the wandering antihero. This genre reaches a countercultural apotheosis at the point where there is no narrative rationale needed for the philosophical seeking of the biker in *Then Came Bronson* (1969–70) and reappears for a brief moment in the paranoid government series with the amnesiac protagonist on the run from the U.S. Security State in the short-lived *Nowhere Man* (1995–96). The oppositional post-9/11 road series still exists today in two recent J. J. Abrams shows, both of which, however, were quickly cancelled. In the first, *Revolution* (2012–14), the characters are constantly in movement as they battle the warlord patriots of the "United States" in a postapocalyptic world. In the second, *Believe* (2014), a man condemned to die is broken out of prison as he is walking to the gas chamber (à la *The Fugitive*'s Richard

"Could I Be Wrong?" *Maverick*'s questioning of the precepts of the American ethos.

Kimble) and teams with a Stephen King *Firestarter* telekinetic prodigy to battle a Dr. Mengele–like head of a corporation (Kyle MacLachlan of *Twin Peaks* fame), who is attempting to turn telekinesis into a weapon for an all-pervading U.S. intelligence agency.

Testifying to *Maverick*'s enduring countercultural credibility, blues musician George Thorogood, in naming an album after the show, affirmed the fact that "Growing up this guy was the coolest guy in my life" (Robertson, 261). Stephen J. Cannell wrote many of the episodes for *The Rockford Files* and went on, in his finest moment, to create *Wiseguy* (1987–90), a post–Iran-Contra Affair series about a government informer that explored various levels of official corruption and was a forerunner of *The X-Files* (1993–2002). Cannell credited Huggins with creating "the first television anti-hero" and claimed that the show "has affected my writing ever since" (Robertson, xvi).

The legacy of *Maverick*'s influence is, however, brief and sporadic, and the examples are not so numerous, especially in the current post-9/11 landscape where the adult Western lawman has reemerged, this time as an urban cop using forensics as well as a revolver to apprehend or gun down the unambiguous "bad guys"—Joe Friday in a lab coat.

The most salient argument for a truly resistant series not being able to sustain a long life is what happened to the show itself. *Maverick* in effect lasted only two seasons, with episodes in the remaining three seasons after Huggins left falling into a more rigid formula and experimenting with Maverick being out of character as sheriff, mayor, soldier so often that it almost seemed to make the "gentle grafter" conform and go straight. What this points to is that television as a commercial medium is a disruptive, stop-and-go alternation of openings and closings rather than a medium with a persistent forward momentum toward progressive themes. The medium is indeed, as Antonio Gramsci characterized popular culture in general, a continual and perpetual "site of struggle" whose liberatory moments rapidly appear and disappear. It is this description that perhaps better delineates the nature of series television rather than the characterization of a persistent and ever-improving site of progressive sophistication that is the contemporary claim of "quality TV," the industry term designed initially to distinguish cable from network television that has by commercial osmosis now come to stamp television as a whole in this supposed new golden age (Polan).

Rather than following the industry line of continual improvement, some series shared fates similar to *Maverick*'s. *Twin Peaks* (1990–91) was mocked in its second season for "losing momentum," but in fact the series thematic of incest at the heart of the American home, illustrated in its naming of the killer of Laura Palmer, was told in fifteen episodes, and its enduring silliness after the thematic was worked out was the result of a constraint that series must run for five years in order to

be syndicated. *Mancuso FBI* (1989–90) was a short-lived series that began in a post–Iran-Contra vein exposing government corruption. However, when the ratings did not immediately soar, the network, NBC, retooled the series to a kind of *Hawaii Five-O* (1968–80) mishmash that had Mancuso, instead of chasing government malfeasance, performing the detective equivalent of retrieving the neighbor's treed cat—that is, finding lost friends' relatives—and the series quickly tanked.

More disturbing was the recent transformation of what at first seemed a *Maverick*-style contemporary Western also about the Gilded Age, AMC's *Hell on Wheels* (2011–). The season one emphasis was on questioning the "progress" of the railroad as it devastated nature and was responsible for the spoliation of Native American land in a set that, in its squalor, looked like the almost cannibalistic fort of the settlers in Jamestown after a winter in the wilderness in Terence Malick's *The New World* (2005). *Hell on Wheels* was told through the perspective of a lead character who was a combination fugitive and avenging angel, with his ire reserved for the Yankee soldiers who had killed his wife and child and were now threatening the Cheyenne. Season two reversed the terms completely with, by the end of the season, the railroad now unapologetically taking the native land that in the season's opening episodes was being questioned. Likewise, the lead character was revealed to be not just a Confederate soldier but also a southern aristocrat who would now himself go over, as the show did, to the side of empire and become the foreman as well as one of the owners of the railroad.

One might also mention Josh Whedon's *Firefly* (2002–3), which in the neoconservative mood after 9/11 dared to side with a gang of *Star Wars*–type rebels pitted against the Alliance, the dominant galaxy power that in its projection of force looked a lot like the United States and its various allies in Afghanistan and Iraq. The show died after one glorious season. Finally, there is the recent quick pulling of the plug by Fox on the series *Rake* (2014), which featured a *Maverick*-style outsider, Keegan Deane

(Greg Kinnear), addicted to gambling, sex, alcohol, and money but also a defense attorney, in the style of *The Lincoln Lawyer* (2011), opposed to corporate law. In one episode, Deane holds his nose and goes to work for his buddy's corporate law firm. He brilliantly wins a case but is subsequently the subject of abject ridicule by the firm, which is indifferent to his winning and angry that he did not draw the case out, his productivity to the corporate firm not measured in the result for the client but in "billable hours." The show, with its disdain for corporate law, was cancelled in less than half a season.

Could *Maverick* be wrong? Is it possible to challenge the dominant precepts of this society in a commercial medium? Perhaps, but given that the nature of corporate rule of television is such that resistant and critical television series are few and far between and may be altered in midstream, *Maverick*'s first two seasons were more than just "quality television." They were a minor miracle.

Notes

Chapter 1

1. This character today is more commonly referred to as a grifter, most prominently in the 1990 film with that title. However, Huggins's own phrase retains the meaning of more widespread corruption, of graft, rather than of simple individual conning and so seems more appropriate for *Maverick*'s Gilded Age take on the generalized illicit speculation that the show argued characterized life in the West.

2. Jack Warner referred to writers as "schmucks with Underwoods" (Garner and Winokur, 49), that is, little more than their writing tool, the typewriter.

3. Thus, the "High Card Hangs" episode of *Maverick* became one season later "Odd Card Hangs" on *The Alaskans* (Robertson, 123).

4. The idea of series endlessly reproducing themselves also has an intergenerational component, and *Maverick* had several less than successful iterations on television before the *Maverick* film in 1994. Garner starred in the TV movie *The New Maverick* on ABC in 1978, in the CBS series *Young Maverick* (1979–80) that did not last even a half season, and finally for about three-quarters of a season on NBC as *Bret Maverick* (1981–82).

5. As for contemporary Warner Bros. hawking its own products, that too proceeds apace. The premiere episode in the fifth and concluding season of *Fringe* (2008–13), supposedly taking place in the future, contained a scene with a loner collector at home watching an episode of the second season of *Maverick,* which featured Clint

Eastwood. This 2012 episode aired just as the studio was releasing a DVD of *Maverick*'s second season, and thus what might be mistaken for whimsy on the part of the *Fringe* writers was more likely a calculated ploy on the part of the studio.

6. Huggins's statement on Kelly was that "Jim Garner was Maverick and Jack Kelly was his brother" (O'Shea). Indeed, the cover photo of the DVD for season four of *Maverick,* with Garner having left the show, is Roger Moore's Beau, not Kelly's Bart.

7. The continued serialization of the female soap opera, though, with its constantly shifting characters, was eventually appreciated as both sophisticated and emotionally satisfying and has more recently been adopted as the preferred series format, especially among cable series.

8. *Maverick* parodied not only its own genre in episodes spoofing *Bonanza* and *Gunsmoke* but also the related violent genre of the crime story, with Bret turning into Joe Friday spoofing *Dragnet* and portraying a mobster in a parody of *The Untouchables.*

9. Hargrove was also famous for his self-referential humor, describing a befuddled Maverick in one teleplay as looking "as if he's lost his place in the script" and in another, in a reference to the show's sponsor, Alcoa, referring to the character as "an itinerant aluminum salesman" (Robertson, 61–62).

10. Huggins claimed that after his initial success in retooling *Cheyenne* he was "left alone," granted autonomy by the studio, and as a matter of principle thereafter he boasted that "the networks were not going to tell me how to do television" (O'Shea).

11. For the Bogart and Cagney battles, see Robert Sklar, *City Boys* (Princeton, NJ: Princeton University Press, 1992).

12. Garner described Warner's testimony as similar to the breakdown of *Caine Mutiny*'s deranged Captain Queeg, who during his own trial was anxiously fingering his ball bearings, "except that Queeg was deserving of sympathy" (Garner and Winokur, 66). Garner knew of what he spoke, since his first real acting job had been in a Broadway production of a play based on the novel.

13. When Garner returned to television with his own production company in *The Rockford Files,* he also sued MCA Universal, which he claimed was like the mafia "only Universal didn't need a gun, just a pencil" (Garner and Winokur, 141). He charged that the studio and its head, Lew Wasserman, were engaged in "creative accounting"

or "flat-out larceny." Garner claimed that its "creative accounting," which failed to show a profit for the hit series, was an attempt by the studio to cheat him out of his returns. He settled handsomely out of court and was pleased "not to put any more paintings on Lew Wasserman's wall" (140).

14. Huggins described being a writer at the studio as "like working in a factory; you were expected to be at your desk at nine o'clock . . . [then] take one hour for lunch and to be there until six" (O'Shea).

Chapter 2

1. The immense popularity of the adult Western on television coincided with and probably prompted the decline of the cinematic Western, which from 1956 to 1959 shrank from 17.5 percent of all Hollywood production in the 1950–55 period to 7.2 per cent (MacDonald, *Who Shot the Sheriff?*, 11). By 1959 the total hours of the Western on television was the equivalent of four hundred feature films, and this was more films than were produced in the 1930s and 1940s during the golden age of the B Western (55).

2. The film has had many different interpretations but was well liked by conservatives including Ronald Reagan, who admired the sheriff's strong defense of the town's property classes despite their own reluctance to support him.

3. There are, of course, earlier examples of resistant Westerns, including a whole cycle of noir Westerns in the late 1940s featuring most prominently Anthony Mann's *Devil's Doorway* (1950) in which a Native American Civil War veteran is eventually driven off his land by jealous townspeople.

4. A contemporary series that also contained revisionist elements was Sam Peckinpah's *The Westerner* (1960), whose flimsy code of honor permitted seducing another man's wife and making off with a long-lost army payroll.

5. The show was created by genre bender and B film impresario Larry Cohen, director of *Its Alive* (1972) and *Q* (1982).

6. Huggins produced the series and, as with *Maverick*, also wrote many of the episodes under the pseudonym John Thomas James (Yoggy, 478).

7. One notable quality of the revisionist Western, particularly those of Sam Peckinpah, was a sense of the closing off of the West in films

that were set in the latter part of the nineteenth century. See particularly *The Ballad of Cable Hogue* (1970), where the aged westerner is ultimately slain not in a gunfight but rather by being run over by an automobile when its driver forgets to put on the emergency brake. Peckinpah's mood was elegiac, but other revisionist Westerns such as the same year's *Soldier Blue* seemed to welcome the passing of these values.

8. There is a marked similarity in the speculative frenzy in land led by the railroad in the United States in this period and the land speculation in the rebuilding of Paris under Napolean III's Second Empire. For a vivid description of the economic and interpersonal chicanery around real estate development in this period, see Émile Zola's *The Kill* (New York: Modern Library, 2005), first published in 1871.

9. This is not to say that some Westerns did not also share an expansive view of time, including in the prerevisionist period *Red River* (1948). However, the use of time as a device that might be seen as altering the character's violent views is most expressly highlighted in the foundational revisionist film *The Searchers,* where the length of the search itself seems to give Ethan time to reflect on the implications of the traditional revenge scenario. This contrasts sharply with Ford's more compressed time as fostering the revenge scheme in *My Darling Clementine* (1946).

10. There is a later spin on the patriarchal Western in *The Big Valley* (1965–69) in which Barbara Stanwyck plays the matriarchal ruler of the ranch. However, she appeared sporadically in the show, most often leaving the running of the ranch to her sons. More typical of the property Western was the evolution of Dale Robertson from "wandering loner" as bank agent at the beginning of *Tales of Wells Fargo* (1957–62) to eventual ranch owner later in the series and finally to railroad owner in *The Iron Horse* (Yoggy, 207).

11. The show, in its con women outwitting local yokels, was also a parody of Stanley Donen's musical Western *7 Brides for 7 Brothers* (1954).

12. The weapon, celebrated in the 1950s, was so dangerous that in the 1920s during Prohibition, the National Firearms Act was passed to limit its use (Yoggy, 256).

13. Huggins claimed that he himself directed a reshoot of the ending so Maverick would look at the audience and also claimed that the

audience loved the audacity of this direct questioning of the violence of the Western (Robertson, 111).

14. *Maverick* followed the Warner Bros. policy of extracting a brief scene from the show as its opening, so the parody episode ingeniously extracted the scene that mocked the standard opening of *Gunsmoke* to make it appear to be the *Gunsmoke* opening and then repeated that scene later in the show.

15. One critic described Chester as a character who "may have bred with kin one too many times" (Yoggy, 86).

16. The farcical quality of the scene anticipates Mel Brooks's *Blazing Saddles* (1974).

17. Chapter 3 contains a more fully developed characterization of Maverick's more liberated Western females, grouped under the category of the flâneuse.

18. As with Maverick's intruding voice-over, there is another reflexive moment when Bret, observing Clyde limping after being stomped on by a horse, says, "That's nice. Kind of gives you character." Clyde then adopts the limp, one of the Chester character's famous quirks, in subsequent scenes.

Chapter 3

1. Not as pointedly perhaps as Honoré de Balzac, who in *The Physiology of Marriage,* the first volume of his novelistic mapping of the period of heightened social inequality that was the Bourbon Restoration in *The Human Comedy,* presents his flâneur as, according to David Harvey, an "aesthete, wandering observer" but one who also seeks "to unravel the mysteries of social relations and of the city" and "to penetrate the fetish" of commodity relations (56).

2. They saw themselves as active, each as a participant who "makes adventures happen" (Jappe, 59), rather than as the 1930s surrealists who sought chance elements in the city in a way that was passive and allowed adventures to happen to them. The difference may have been the difference in commodity culture, which in the 1930s could still have benevolent shadings and evoke discoveries of the differentiation of the past. In Debord's time, that culture was more oppressive and homogenous and required an active engagement to subvert it.

3. The prime example of literary *détournement* is to be found in the style of Guy Debord's major philosophical contribution *The Society of the Spectacle* (Detroit: Black and Red, 2000), which operates through a continual rephrasing of the words and currents circulating within contemporary radical circles in the Paris of his time.
4. A proto–dog robber of a later era is the Joaquin Phoenix character in the antimilitary Miramax film *Buffalo Soldiers* (2001), which in its critique of the army and the Cold War was nearly the last of its kind, having been shot before 9/11 and released to little fanfare afterward.
5. Dehner, whose casting always connoted evil on the series, was used later in the show as the corrupt Indian trader who provokes a war between the Indians and the calvary that results in the massacre of both in the two-part episode "The Devil's Necklace" in season four.
6. The episode's title credits trumpet this collective by reinstating the 1930s Warner Bros. screen habit of identifying actors at the beginning of the film with their image. Here, the family of cons is identified by name over an image of each from a previous episode.

Chapter 4

1. American broadcasting, which had maintained a more neutral stance toward government in the 1930s, though government-produced programs marked as such were frequent, abandoned that stance in World War II when, for example, the Office of War Information, the main propaganda arm of the government, sent out "fact sheets" three times a month to radio writers that would be incorporated into programming. This close connection maintained during the Cold War has returned again, with the U.S. Central Intelligence Agency and the Pentagon lending access and support to American television in a new cold war after 9/11 (Broe and Spence). The 1950s tropes will no doubt again be a factor in what now looks like a more exact replaying of the Cold War as Russia again moves front and center as the enemy, this time rationalizing the permanent war economy. This latest cold war, now shorn of any ideological pretensions, is, to paraphrase Marx, a third time as neither tragedy nor farce but simply naked projection of (declining) American power.
2. The impetus for John Ford's questioning of the genre in *The Searchers,* in which the John Wayne character is both in command and

overtly brutal and cruel, may have been President Truman's removal of General Douglas MacArthur, who during the Korean War wanted to invade China and was judged as being dangerously confrontational (Corkin).

3. In the period when *Maverick* entered the airwaves, the United States was just beginning to be involved with halting movements for colonial independence, a trajectory that would lead to the tragedy of the Vietnam War. In its view of the colonized peoples of the West, the Native Americans, the show reduced them to neither noble savages nor indistinct cannon fodder as many of the other Westerns did. Instead, *Maverick* tended to treat them as equally as moral or as corrupt as the Europeans. As Garner described his character, "He isn't anti-Indian, and neither am I, being one quarter Cherokee" (Garner and Winokur, 54).

4. Huggins had wanted to title the film the far more pessimistic "Nothing but the Night" from a poem by A. E. Housman: "O never fear, lads, naught's to dread, / Look not left nor right: / In all the endless road you tread, / There's nothing but the night" (O'Shea).

5. Huggins's other *film gris, The Lady Gambles* (1949), a remake of the precode *Gambling Lady* (1934) and both with Barbara Stanwyck, is perhaps a prelude to *Maverick*. The film has a similar subject matter but with a heavier mood that again lays bare a society that creates "hard" characters, as the Lizbeth Scott wife in *To Late for Tears* is described, who desperately want what society advertises as its (unavailable) fruits. The film is a flashback account told by her husband of how Stanwyck's female gambler has become so consumed with the idea of money for nothing that she is found, in the opening, beaten in the alley outside a club for using loaded dice.

6. Though the series at points may have had liberal writers with a social point of view such as James Moser, that viewpoint had to be integrated into an overall repressive celebration of one of the most regressive (and racist) police departments in the country. The show's conservative credentials were highlighted when it became one of the models for a new militarization of television after 9/11 (Broe, "Genre Regression and the New Cold War"), even briefly surfacing in its third television iteration, which mercifully did not last even a single season.

7. Webb also enlisted Jack Kelly in his law-and-order Cold War paranoia crusade the year after *Maverick* ended, as he starred in the

Webb-narrated *Red Nightmare* (also known by its campier title in a later video release in 1985, *The Commies Are Coming, The Commies Are Coming*) in which Kelly awakes to find America taken over by communists. Kelly was later to participate in a kind of opposite nightmare in which America was taken over by greedy land developers, when, aided by his real estate broker wife, he ran successfully for mayor of Huntington Beach on the slogan "Let Maverick Solve Your Problems."

8. For a more detailed account, see David Marc and Robert J. Thompson's *Prime Time, Prime Movers* and the concluding chapter of my own *Film Noir, American Workers, and Postwar Hollywood.*

9. Again, there was an extratextual relationship between the two shows. Stephen Cannell, who wrote the pilot for *The Rockford Files* and was its primary author, cut his Hollywood teeth writing *Adam-12,* where he learned the rules of the police docudrama only to subsequently and gleefully break them.

10. Throughout, the series contained in embryo aspects of *The Fugitive,* with the Maverick brothers or their acquaintances portrayed as refugees from the law. The series' intended pilot, "Point Blank," contains a backstory of Bret fleeing a lawman that was later dropped but did appear in the brothers explaining that they were erroneously still wanted for a murder in Texas in "Trail West to Fury." "Burial Ground of the Gods," or *The Fugitive Goes West,* recites the story of a convicted murderer sentenced to hang who escaped when the Sioux attacked the stagecoach taking him to the gallows, as Richard Kimble was freed by a train wreck on his way to execution. Finally, "Naked Gallows" has Bart attempting to clear a falsely accused man he met on a hunting trip.

11. This plot was later rerun on an episode of *Alias Smith and Jones.*

12. Played by Louise Fletcher, who later and most infamously portrayed Nurse Ratched in *One Flew over the Cuckoo's Nest* (1975).

BIBLIOGRAPHY

Andersen, Thom. "Red Hollywood." In *Literature and the Visual Arts in Contemporary Society,* edited by Suzanne Ferguson and Barbara S. Groseclose, 158–65. Columbus: Ohio State University Press, 1985.

Anderson, Christopher. *Hollywood TV: The Studio System in the Fifties.* Austin: University of Texas Press, 1994.

Baudelaire, Charles. *The Painter of Modern Life and Other Essays.* London: Phaidon, 1964.

Bazin, Andre. "The Evolution of the Western." In *The Western Reader,* edited by Jim Kitses and Gregg Rickman, 46–56. New York: Limelight Editions, 1996.

Benjamin, Walter. *Charles Baudelaire: A Lyric Poet in the Era of High Capitalism.* Translated by Harry Zohn. London: Verso, 1983.

Brand, Dana. *The Spectator and the City in Nineteenth-Century Literature.* Cambridge: Cambridge University Press, 1991.

Broe, Dennis. *Film Noir, American Workers, and Postwar Hollywood.* Gainesville: University Press of Florida, 2009.

———. "Genre Regression and the New Cold War: The Return of the Police Procedural." *Framework* 45, no. 2 (2004): 81–101.

Broe, Dennis, and Louise Spence. "In Focus: Media and the New Cold War." *Cinema Journal* 43, no. 4 (2004): 96–136.

Burgoyne, Robert. *Film Nation: Hollywood Looks at U.S. History.* Minneapolis: University of Minnesota Press, 1997.

Cawelti, John G. *The Six-Gun Mystique.* 2nd ed. Bowling Green, OH: Bowling Green State University Popular Press, 1984.

Charters, Ann, ed. *Beat Down to Your Soul: What Was the Beat Generation?* New York: Penguin, 2001.

Combs, Richard. "Retrospective: *High Noon.*" In *The Western Reader,* edited by Jim Kitses and Gregg Rickman, 167–72. New York: Limelight Editions, 1996.

Corkin, Stanley. *Cowboys as Cold Warriors.* Philadelphia: Temple University Press, 2004.

Durgnat, Raymond, and Scott Simmon. "Six Creeds That Won the Western." In *The Western Reader,* edited by Jim Kitses and Gregg Rickman, 69–83. New York: Limelight Editions, 1996.

Edgerton, Gary R. *The Columbia History of American Television.* New York: Columbia University Press, 2007.

Elsaesser, Thomas. "Tales of Sound and Fury." In *Film Genre Reader,* edited by B. Grant, 278–308. Austin: University of Texas Press, 1986.

Felheim, Marvin. "Introduction." In *The Gilded Age,* Mark Twain and Charles Dudley Warner, vi–xviii. New York: New American Library, 1969.

Garner, James, and Jon Winokur. *The Garner Files.* New York: Simon and Schuster. 2011.

Gramsci, Antonio. *Selections from the Prison Notebooks.* London: Lawrence and Wishart, 1971.

Harvey, David. *Paris: Capital of Modernity.* New York: Routledge, 2003.

Harvey, Sylvia. "Woman's Place: The Absent Family of Film Noir." In *Women in Film Noir,* edited by E. Ann Kaplan, 22–34. London: British Film Institute, 1978.

Hoberman, J. "How the Western Was Lost." In *The Western Reader,* edited by Jim Kitses and Gregg Rickman, 85–92. New York: Limelight Editions, 1996.

Holmes, John Clellon. "The Philosophy of the Beat Generation." In *Beat Down to Your Soul: What Was the Beat Generation?,* edited by Ann Charters, 228–38. New York: Penguin, 2001.

———. "This Is the Beat Generation." In *Beat Down to Your Soul: What Was the Beat Generation?,* edited by Ann Charters, 222–28. New York: Penguin, 2001.

Horowitz, David. *Corporations and the Cold War.* New York: Monthly Review Press, 1969.

Jappe, Anselm. *Guy Debord.* Berkeley: University of California Press, 1999.

Josephson, Matthew. *The Robber Barons: The Great American Capitalists, 1861–1901.* New Brunswick, NJ: Transaction Publishers, 2011.

Kitses, Jim. "Introduction: Post-Modernism and the Western." In *The Western Reader*, edited by Jim Kitses and Gregg Rickman, 15–31. New York: Limelight Editions, 1996.

Lafargue, Paul. *The Right to Be Lazy*. New York: Charles Kerr, 1883. Available at www.marxists.org/archive/lafargue/1883/lazy/index.htm.

MacDonald, J. Fred. "Television and the Red Menace: The Video Road to Viet Nam." J. Fred MacDonald Presents, 1985, http://jfredmacdonald.com/trm/index.htm.

———. *Who Shot the Sheriff? The Rise and Fall of the Television Western*. New York: Praeger, 1987.

Marc, David, and Robert J. Thompson. *Prime Time, Prime Movers: The Inside Story of the Inside People Who Made American Television*. Syracuse, NY: Syracuse University Press, 1995.

Melville, Herman. *The Confidence Man*. New York: Grove, 1961.

Mitchell, Lee Clark. *Westerns: Making the Man in Fiction and Film*. Chicago: University of Chicago Press, 1996.

Moore, Roger. *My Word Is My Bond*. London: Michael O'Mara, 2009.

Navasky, Victor. *Naming Names*. New York: Viking, 1980.

O'Shea, Tim. "Archive of American Television Interview with Roy Huggins." Talking with Tim, February 16, 2011, http://talkingwith-tim.com/wordpress/2011/02/16/archive-of-american-television-interview-with-roy-huggins.

Polan, Dana. "Cable Watching: HBO, the Sopranos and Discourses of Distinction." In *Cable Visions: Television beyond Broadcasting*, edited by Sarah Banet-Weiser, 261–83. New York: New York University Press, 2007.

Robertson, Ed. *Maverick, Legend of the West*. n.p.: Self-published, 2012.

Server, Lee. *Robert Mitchum: "Baby I Don't Care."* New York: Macmillan, 2002.

Strait, Raymond. *James Garner*. New York: St. Martin's, 1985.

Twain, Mark, and Charles Dudley Warner. *The Gilded Age: A Tale of Today*. New York: New American Library.

Wark, McKenzie. *The Beach Beneath the Street: The Everyday Life and Glorious Times of the Situationist International*. London: Verso, 2011.

Watson, Steven. *The Birth of the Beat Generation: Visionaries, Rebels, and Hipsters, 1944–1960*. New York: Pantheon, 1995.

"William Boyd & Hopalong Cassidy." The Old Corral, www.b-westerns.com/hoppy1.htm.

Williams, William Appleman. *The Tragedy of American Diplomacy: 50th Anniversary Edition*. New York: Norton, 2009.

Wilson, Elizabeth. "The Invisible Flâneur." *New Left Review* 1, no. 191 (1992): 90–110.

Wooley, Lynn, Robert W. Malsbary, and Robert G. Strange Jr. *Warner Bros. Television*. London: McFarland, 1985.

Yoggy, Gary A. *Riding the Video Range: The Rise and Fall of the Western on Television*. London: McFarland, 1995.

INDEX

119